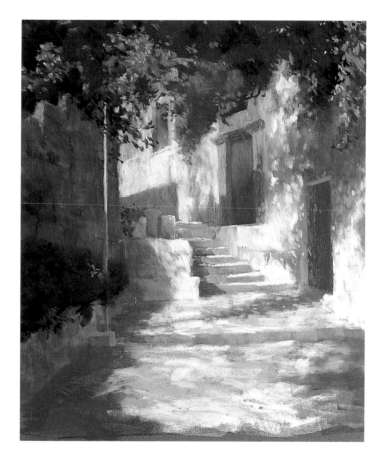

Introduction by Ian Sidaway

David & Charles

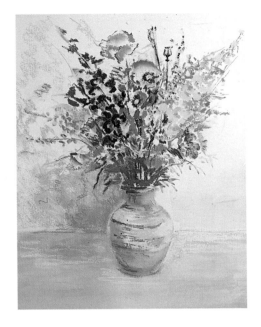

A DAVID & CHARLES BOOK

First published in the UK in 2000

Picture credits: front cover Brian Busselle;
back cover Frances Treanor (left), Jackie Simmonds (middle), Mike Pope (right);
title page Jackie Simmonds; this page Diana Constance; contents page Kay Gallwey

A catalogue record for this book is available from the British Library.

ISBN 0 7153 1149 2

Designed, edited and produced by Eaglemoss Publications Ltd,
based on the partwork *The Art of Drawing and Painting*

Printed in the Slovak Republic by Polygraf Print spol. s. r. o.
for David & Charles
Brunel House
Newton Abbot
Devon

10 9 8 7 6 5 4 3 2 1

CONTENTS

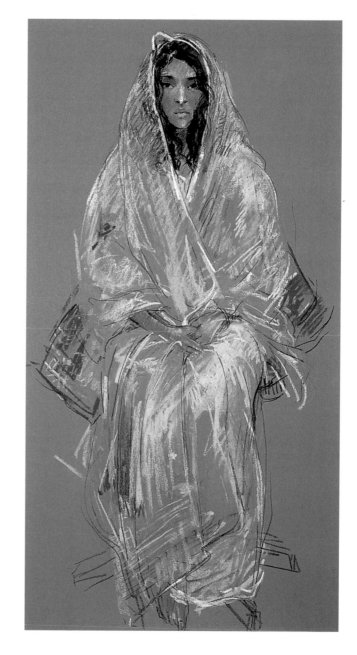

INTRODUCTION

Inspiration for the artist can come from the most unexpected quarter, including from the very materials he or she chooses to work with. Few artists' materials can be more stirring than a box of new pastels, which when opened reveals regimented rows of intense, sparkling, clean colours. With their precious, almost jewel-like, quality, pastels seem to be practically crying out to be picked up and used.

Pastel is a unique medium, comfortably straddling the fence between drawing and painting. While many of the application techniques employed feel like and owe much to drawing, other techniques are more akin to those used in painting. Indeed, finished pastel works are often referred to as paintings.

Working with pastel is a pleasingly tactile experience and the results are immediate. Whereas other coloured painting materials need to be mixed or prepared beforehand on a palette, a pastel painting is created by the manipulation of the pastel directly on the support. Pastel is also a very versatile medium in terms of both colour and effect. Although the word pastel is commonly used to mean pale and delicate, pastels are equally capable of producing work that is solid and bold, and possessed of great depth, strength and intensity of colour. And the very nature of the medium makes it an extremely flexible one, which with practice and a degree of technique can produce works ranging from the broad and expressive to the intimate and highly realistic, from the carefully crafted to the fast and frenetic. Working with pastels also requires very little auxiliary equipment, making them not only of use in the controlled environment of the studio or work room but also the ideal material for sketching or working on location.

As for handling pastels, they are remarkably simple to use. Due to the complex characteristics of oil, acrylic or watercolour paint, certain rules and sequences of application need to be followed when using these materials. In contrast, the technical knowledge needed to work with pastel is very slight. You choose your colour, and you make your mark – it really is as simple as that. That said, many pastel techniques echo those used for working with other materials, so if you have worked with oils, watercolour or acrylic, then the techniques of scumbling, glazing and impasto, to name but a few, will already be familiar to you.

Apart from oil pastels, all other 'dry' pastels, be they soft or hard, large or small, square or round, pencil or sticks, can be intermixed, as can the many different brands. Given that one manufacturer lists over 550 different tints and tones, the range of colours available for use should satisfy even the most discerning artist.

It would be wrong to describe pastel as an easy medium to use, but it is straightforward. It is a material that can be at once fascinating and infuriating, and one that is constantly revealing another side to itself which, regardless of whether you are a beginner or a professional, makes every time you work with it an exciting voyage of discovery.

Ian Sidaway,
London

CHAPTER ONE

Pastels & pastel papers

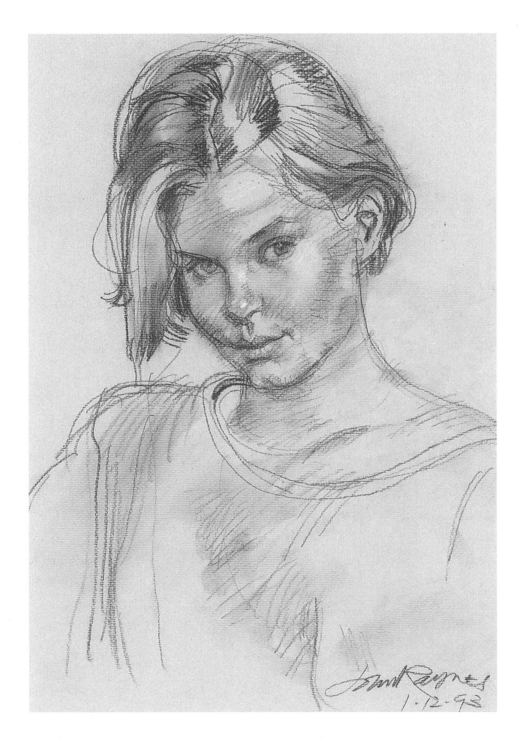

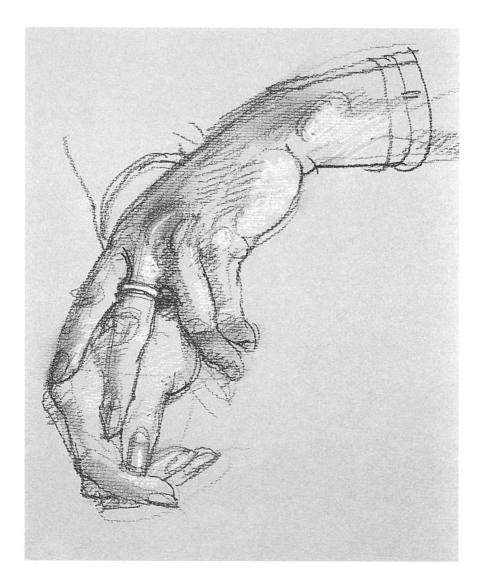

Soft pastels – *pure colour*

Artists' pastels provide colour in its most intense form, and in a range from soft, powdery pinks to deep velvety purples.

▼ The great attraction of pastels is the freshness and immediacy of their colours – evidence that they are almost pure pigment. Beautifully blended colours give soft flesh tones, complex webs of textured colour bring the background alive, while fine linear strokes depict folds in the clothing of mother and child.

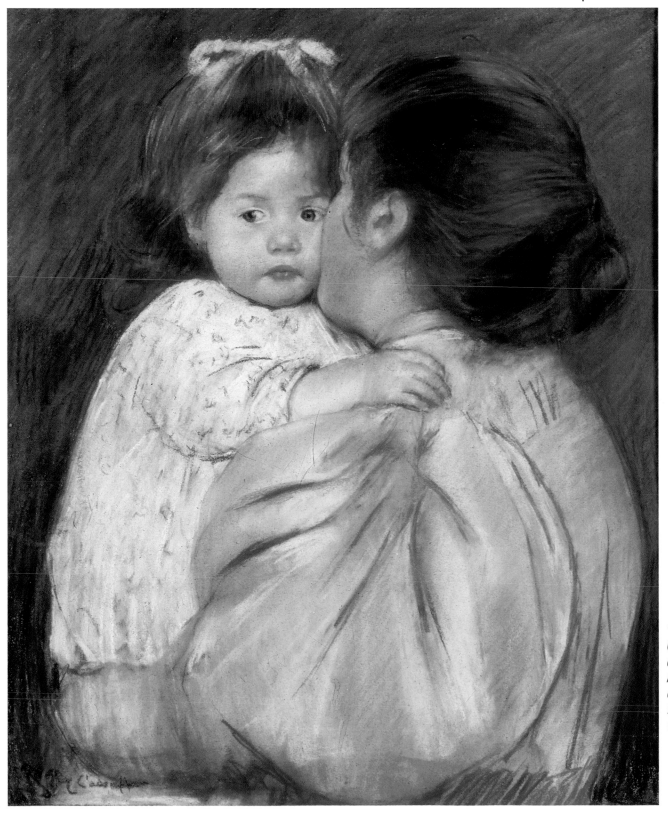

'Maternal kiss' by Mary Cassatt, 1896. Pastel on paper, Philadelphia Art Gallery, Bequest of Anne Hinchman, 56 x 46.25cm (22 x 18 ¼in)

▶ Almost every imaginable colour is available in pastels – this is because you can't mix different colours with each other as you do with watercolour and oil paints.

These are artists' pastels, which are much more costly than the students' range, but you can buy them one at a time and build up your own collection gradually.

▼ For the beginner, a box of 24 pastel sticks provides plenty of scope.

Pastels are pigment powders bound together in stick form with gum or resin. Soft pastels are made with relatively little binder, which is why they have a light, crumbly texture – and why the colours are so pure.

As a sketching and drawing medium, pastels are extremely versatile. By using the broad end of the stick, you can create a wide line of coarse crumbly texture. Or you can work with the edge of the stick to make a mark as fine and delicate as one drawn with a pencil. You can even draw a line of thicks and thins by varying the pressure, or by turning and changing the angle of the pastel stick as you draw.

Soft pastels are available in a vast range of colours and tones, and large expanses present no problem – with the stick laid on its side, you can rapidly fill them in with layer upon layer of rich velvety colour.

Colour mixing

With pastels, the manufacturer does the mixing for you, which is why they come in such a wide range of colours and tones. One manufacturer makes 60 basic colours, with three to ten darker and paler versions of each one.

Such a choice can be bewildering and is certainly personal. Some artists use a huge selection of colours and tones, while others are happy with a limited choice.

The basic kit

One of the great advantages of pastels is that you don't need a lot of equipment. Your basic requirements are the pastels themselves and a sheet of paper.

You do need a drawing board or other rigid support for your paper. Whether you also use an easel or not depends on whether you prefer to work horizontally or vertically. Easels have one main plus point – pastels create a lot of dust which can fall straight to the ground when the drawing is worked on vertically.

One final thing you need is fixative, available from art shops. This fixes pastel to paper and does away with the risk of smudging. Don't overuse as it can darken the picture.

Pastel paper

Pastels are a dry medium, so the paper surface must be textured enough to hold the pigment particles in place. Pastel papers have a surface with a definite key ('tooth'), which is designed to capture and hold the tiny particles of colour. These papers allow you to build up several layers of pastel to a dense, matt finish.

White chrysanthemums in a vase

This picture demonstrates neatly that you don't need a vast repertoire of pastel drawing techniques to create an attractive result. The image is made up of a few basic marks, which are well worth practising before you start.

Setting up

To carry out this project, you can either copy our bunch of flowers or set up a subject of your own at home. Our artist chose a glass vase to draw because of the way the light reflects on it, creating interesting patterns. But if you want to make life easier for yourself, you could use an opaque vase. (This means you don't have to worry about drawing in the bottom of the flower stems.) Make sure your still life is well lit. And check that you can see it properly. You also need enough light to work in.

The colour of the paper should contribute something to the final image. The artist here went for green, which holds the whole picture together behind the foliage and flowers. A white background would look too stark.

Before you start drawing, stand well back from the vase. Half-close your eyes and look for its overall shape and form. Look out for the lights and darks, too. Now come in a bit closer. Have your pastels to hand and look for the colours for the petals, leaves and so on.

Pin the paper to the drawing board. It's now worth spending a few moments working out where you're going to position the image in the paper area. You don't want the vase slipping off the bottom of the page, for instance. If it makes you feel more comfortable, draw in an outline with charcoal or Conté crayon.

Once you start, keep studying the flowers intently. Try not to concentrate too much on individual areas, though. Instead look at how the whole picture is building up.

YOU WILL NEED

☐ 750mm x 550mm (29½ x 21¾ in) mid green pastel paper

☐ 12 pastels including white, cadmium yellow lemon, lizard green, olive green, pale cool grey, Hooker's green, green grey, yellow green, dark cool grey, burnt umber, yellow ochre

☐ Spray fixative

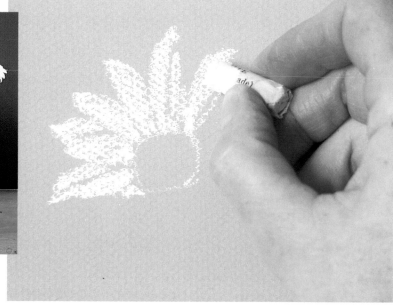

▲ The set-up

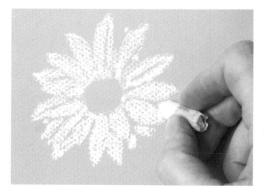

◄ **1** Draw circles for the flower centres with white pastel. Follow with some simple petal outlines, then fill them in loosely. If you're working on a horizontal surface, blow away any excess dust.

(To avoid smudging your drawing, roll up your sleeves before starting and try not to rest your hand on the paper.)

▲ **2** Continue drawing petal shapes and filling them in until you've completed the first flower. There's no need to make every petal exactly the same size and shape.

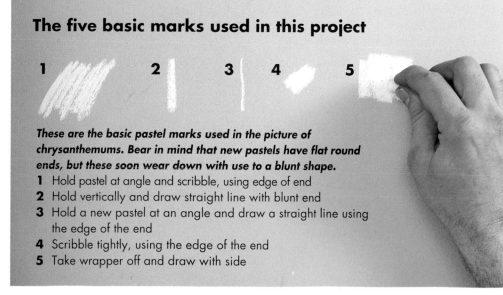

The five basic marks used in this project

1 2 3 4 5

These are the basic pastel marks used in the picture of chrysanthemums. Bear in mind that new pastels have flat round ends, but these soon wear down with use to a blunt shape.

1 Hold pastel at angle and scribble, using edge of end
2 Hold vertically and draw straight line with blunt end
3 Hold a new pastel at an angle and draw a straight line using the edge of the end
4 Scribble tightly, using the edge of the end
5 Take wrapper off and draw with side

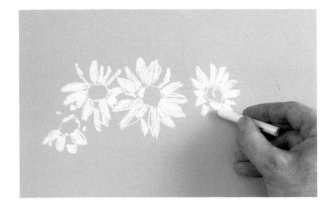

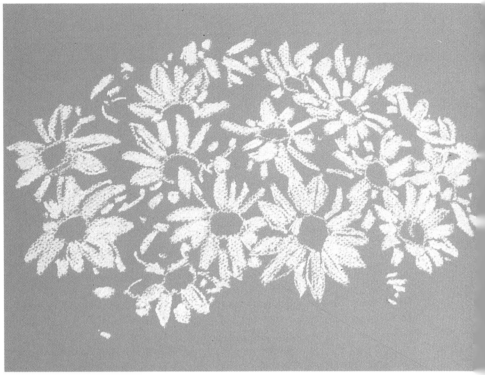

▲**3** Draw in some more flowerheads, but don't feel you need to reproduce every single one exactly – you're not doing a botanical drawing. Quick marks can often trigger the whole image and be effective and lively.

▶**4** When you've drawn in all the flowerheads, spray the picture with fixative, following the maker's recommendations.

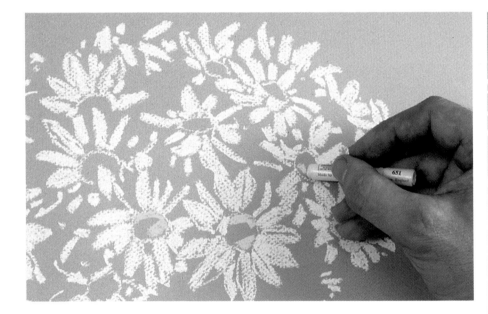

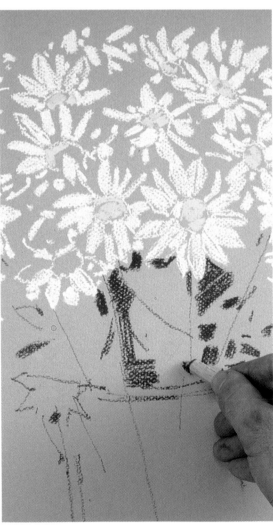

▲**5** Look closely at the centre of the chrysanthemums for lights and darks. Now go across the drawing, putting them in with blobs of lemon and cadmium yellow.

Add a blob of lizard green at the very heart of each flower. Notice how the drawing now feels as if it's coming together, with the green paper playing its part.

▶**6** Stand well back and half-close your eyes. Look for lights and darks in among the stems and leaves. Then, using olive green, roughly draw in some of the leaves and stems and part of the vase. Start to fill in the darker background shapes between the leaves with the olive green.

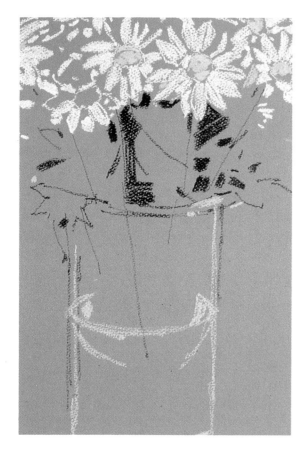

◄7 Continue drawing in all the lighter parts of the glass vase using a pale cool grey.

▼8 With Hooker's green, draw in some patches of the green stems and leaves in the vase.

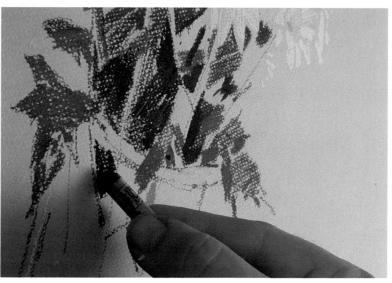

►9 Still using Hooker's green, indicate some of the chrysanthemum leaves (but don't try to put in every one!). Now continue the background around the stems with green grey.

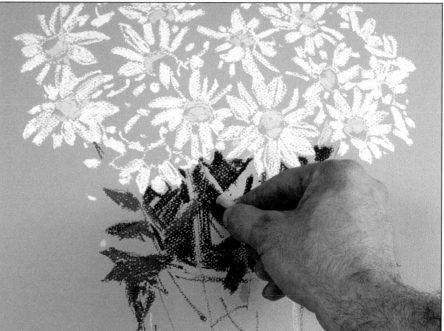

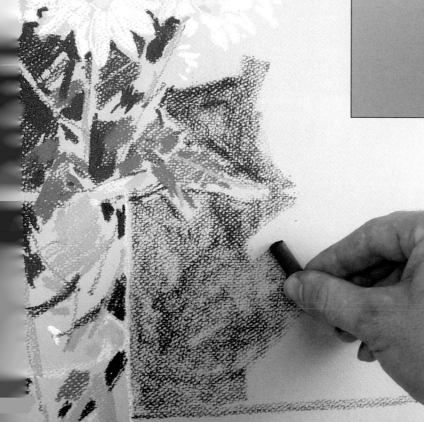

◄10 Add emphasis to the stems with yellow green. Put in some of the darker patches of water with a dark cool grey. Now use the green grey to continue the background among the petals.

With burnt umber, add darker touches to the background showing through the vase. Then using the same pastel on its side, lightly put in all the background above the table top, carefully filling in among all the outside petals. Move the pastel in different directions to build up a web of colour with varying lights and darks. Don't worry about the texture of the paper showing through – this all adds to the effect.

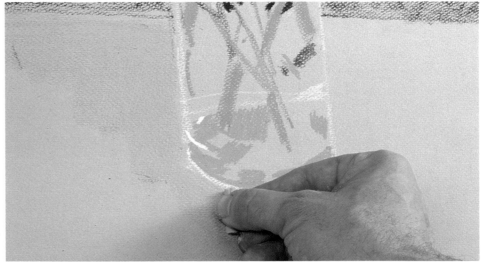

► **11** Block in the table top with yellow ochre. Again use the side of the pastel, but this time apply more pressure so you end up with solid colour.

▲ **12** To represent the grain of the wood, draw in a few lines with burnt umber. Finish off the bottom of the vase by adding white highlights and green grey shadows.

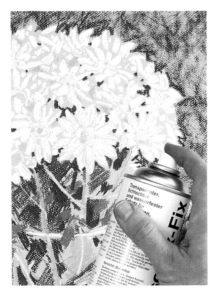

▲ **13** Spray the finished picture with fixative, following the manufacturer's instructions.

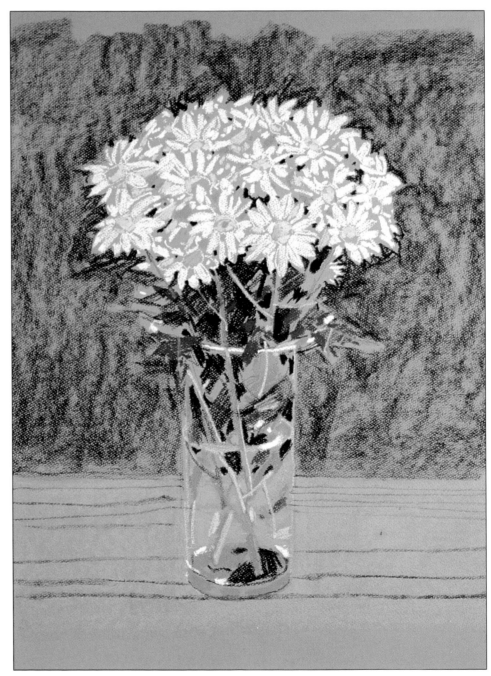

A guide to pastels

Choosing from the huge range of pastels available can be as confusing as a cryptic crossword! Our guide to pastels outlines the main varieties – and the differences between them.

When you try to learn more about the pastels available, it can seem as if the manufacturers are out to confuse you! You may be stumped immediately by the long list of names – soft pastels, hard pastels, chalk pastels, pastel chalks, Conté crayons, pastel pencils, pastel crayons and square pastels – and by what they all do.

To simplify matters, we have split up the wide range of pastels which are available into three groups – those that are either **round** or **square** in cross-section, and **pastel pencils**. We have chosen this classification because the different shapes are suited to particular ways of drawing, and so determine, to an extent, the way you use them.

Hard and soft

Another determining factor is that of hardness and softness. Pastels are made with powder pigment and a binder. The higher the binder content, the harder the pastel. Hard and soft pastels are different in the way they feel in use, and in the effects they create.

With soft pastels (like those used in the demonstrations shown in this chapter), the colour crumbles off smoothly and easily, covering the paper rapidly. It sinks into many of the tiny pits of toothy pastel paper, leaving a film of dust to blow away. With the same amount of pressure on a hard pastel, you'll find it has a slightly scratchy feel and covers the paper less readily. It catches the tooth of the paper, sinking less into the pits to leave a quite grainy effect.

Some manufacturers grade their pastels as hard, medium or soft. However, one manufacturer's 'hard' can be the same as another's 'medium', for instance, so it's best to try them out for yourself on the pads of paper provided in art shops.

Round pastels

These tend to be the softest, and are widely known as artists' soft pastels. Traditionally, they were made by the artists themselves. They come in different widths and range from soft to very

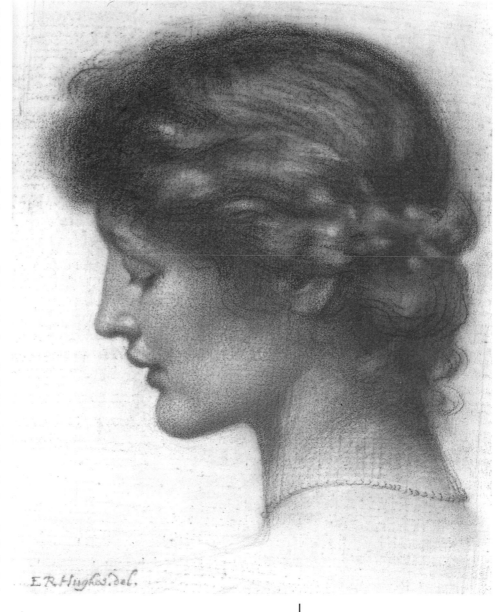

▲ Using just one coloured chalk with very careful handling, the artist has created a wide range of tones, producing a convincing three-dimensional image. Notice the contrast between the clear skin and textured hair.
'Rosalind' by E.R. Hughes, red chalk on board, 24.75 x 19.75cm (9 ¾ x 7 ¾in), courtesy of Peter Nahum at the Leicester Galleries, London

crumbly. Their softness makes them less suited to linear work. You can use a sharpened corner for details, but it wears down quite quickly.

This type of pastel really comes into its own when used for broad areas of brilliant colour. You can work with the side of the pastel, laying wide bands of colour, or use shorter, broken bits in the same way on a smaller scale. Using the tip gives you control for details. The softness of the round variety makes them ideal for blending and smudging with your fingers or a torchon.

◀▼ **The chalks used by Michelangelo and Leonardo da Vinci were the ancestors of the square pastel. The square shape makes for a versatile drawing tool – you can use the tip, the flat of the tip, the side or a side corner for a wide range of marks. Square pastels come in a range of bright colours, as well as some earth colours, black, white and several greys.**

The clean-hand alternative to hard and soft pastels is the pastel pencil. Use pencils with other pastels to add detail, or by themselves for loose drawings and sketches.

Square pastels

Often known as chalks, chalk pastels or Conté crayons, these are generally, though not always, harder than round pastels. They feel chalkier and cover the paper less rapidly.

This variety of pastel is a traditional drawing tool. It's the modern-day equivalent of materials used by Leonardo da Vinci, Michelangelo and Raphael in their famous drawings. In fact, they are available in the same earth tones, evocatively named by one manufacturer as burnt sienna, burnt umber, bistre and sanguine. You can also buy them in black, grey, white and a variety of bright colours.

These are excellent for drawings and sketches in line and tone, and are often used to add detail to soft pastels paintings. They can be sharpened to a fine point for line drawing, and you can hatch and smudge with them to create blended tones. The chalky pastel line is soft and expressive, with a powdery texture, velvety smooth finish and great intensity of colour.

Pastel pencils

These are, quite literally, pastels in pencil form. They tend to be harder than round pastels, making them good for complex line work, detail and shading. They are non-waxy and can be blended and softened with water. In use they have a slightly scratchy, chalky feel, very different from the smooth flowing feel of coloured pencils.

Pastel pencils have the intensity of colour associated with soft pastels and are a marvellously expressive medium. They're excellent for direct,

bold sketches or for dense, detailed drawings with subtle nuances of tone rendered with careful shading and broken colour. They can be used with round or square pastels, but you'll find yourself in trouble if you try to combine them with coloured pencils. The waxy surface created by coloured pencils resists the pastel pencil, causing it to slip and slide.

Papers

Traditional pastel paper, available from art shops, is a soft, fibrous paper that helps the adhesion of the pigment. It comes in different colours and grades. The fine grade is for line work; the coarser grade for broad, free strokes. The coloured sheets provide a good toned ground, rather like using a preliminary colour wash in painting. Your colour choice should enhance the subject of the picture.

You can also buy some specialist papers with coatings to add different textures. Marble dust and velour paper are two examples. (For more on pastel papers, see pages 35–38.)

Storing and sharpening

Pastel pencils are easy to store – just tie them up with an elastic band and place them point up in a jam jar. Round and square pastels are a bit more of a problem. Storing them together in a tin, for example, is a bad idea, since dust comes off the pastels quite easily, which can cause the colours to contaminate each other. The best way to store them is

according to colour. Keep your greens and blues separate from your reds and oranges, and so on. Store them in a shallow plastic box or wooden tray filled with dry rice. Any pastel dust comes off on the rice, rather than on the other pastels.

With all varieties of pastel, it's a good idea to avoid pencil sharpeners for sharpening, since they tend to blunt the blade. Use sandpaper (glasspaper) or a craft knife.

▼**Artists' soft pastels – round in shape – can't be beaten in terms of colour intensity. The crumbly colour is almost pure pigment. With so many different ranges, sizes and tempting colours to choose from, you may find you spend a lot more money than you bargained for. Try them out first, since they vary in softness.**

Portrait in sanguine pencil

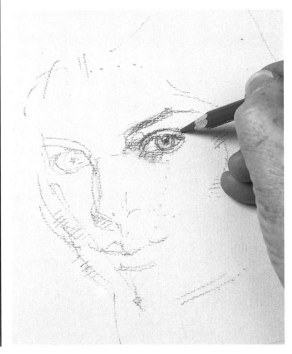

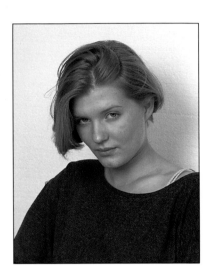

▲ **The set-up** The artist, John Raynes, asked the model to shift her position until he found a pose he liked – a three-quarter view, with her head tilted. It's worth spending time finding a pose you find interesting.

In this demonstration the artist used just one classic pastel colour – sanguine – with a touch of white for subtle highlights. He picked a warm beige paper – again a traditional choice for this type of drawing.

▲ **1** Use the sanguine pastel pencil to establish the basic inverted triangle of the face – measure from the side of each eye to the chin. Use light marks at first so you're not committed to them. Re-check your proportions until you're sure they're correct, then sketch in the main outlines of the face. Focus on the eyes, blocking in the lights and darks.

▲ **2** Work up the eye and eyebrow to your left, then soften the marks around the eye to your right by smudging them with your finger. Apply loose lines to block in areas of dark tone on the face – on the turn of the cheek and under the nose, lower lip and chin. Use widely spaced but regular lines to indicate the dark tones on the forehead.

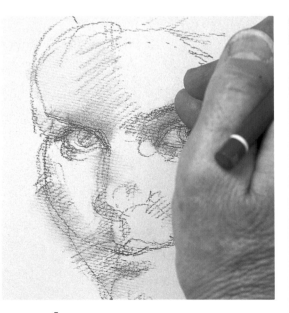

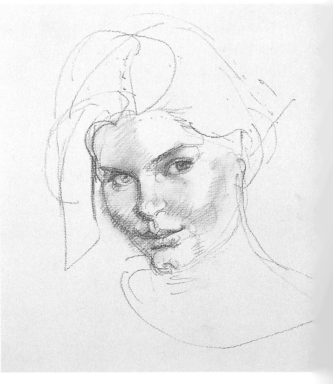

▶ **3** Soften the areas of dark tone around the face by blending the lines with your finger. Pastel pencils are fairly soft and powdery – excellent for smudging and blending.

▶ **4** Sketch in the hair. This is a very distinctive feature so try to avoid the temptation to treat it as a flat, superficial pattern. Notice how, with just a few lines, the artist gives the hair a sense of shape and volume.

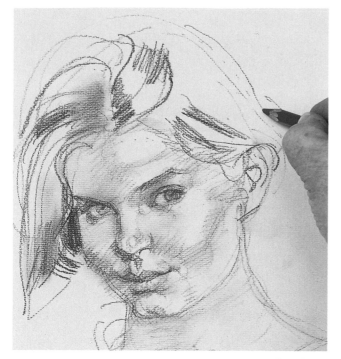

◀ **5** Work on the face as you did before, smudging lines for areas of tone to make it look three-dimensional. Once you're satisfied with the face, start to add detail to the hair. Use less or more pressure on the pastel pencil to make light and dark lines which follow the form of the hair. These tones, especially the dark ones, help to give the hair volume.

YOU WILL NEED

- ☐ An A3 sheet of warm beige Artemedia art & pastel paper
- ☐ Conté à Paris sanguine drawing pencil
- ☐ White square pastel

▼ **6** Add more dark tones to the face to build up its rounded quality, then, using your white square pastel, put on a few subtle highlights where the light catches the model's forehead, nose and eye.

Lightly sketch in the model's shoulder and T-shirt, smudging in a few tones where appropriate. Don't work up this area too much, so the emphasis remains on the face.

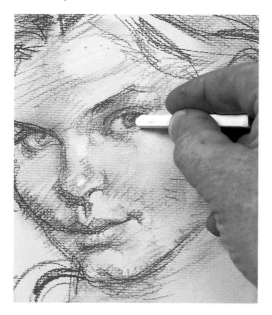

▶ **7** This traditional monochrome approach creates a charming result in the final drawing. The sanguine line has a natural and seductive appeal, with the few touches of white highlight finishing it off wonderfully well.

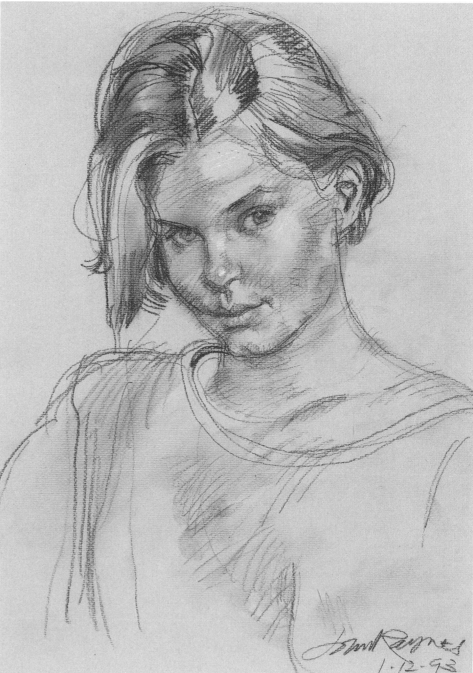

Study of hands

YOU WILL NEED

☐ *An A3 sheet of taupe Artemedia art & pastel paper*

☐ *One Conté pastel pencil: umber 32*

☐ *White square pastel*

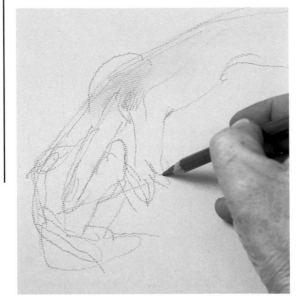

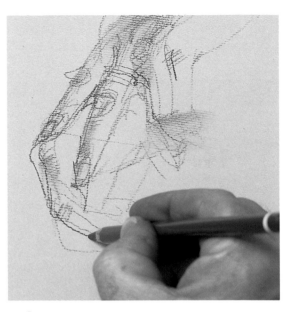

▶ **1** Draw the broad outlines of the two hands lightly with the umber pencil, seeing them as a single form. Measure and re-check all the time between one point and another.

▲ **2** Begin to suggest details such as the fingernails, the ring and the lines on the hands. Half-close your eyes so you can see the planes of light and dark on your subject. Then scribble on the dark tones and smudge them with your finger. As the drawing progresses you can use darker, more emphatic lines.

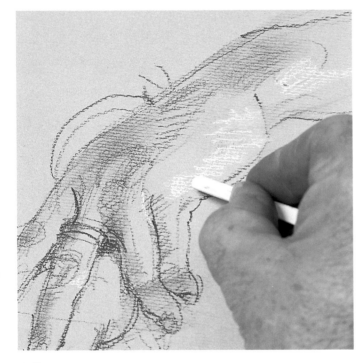

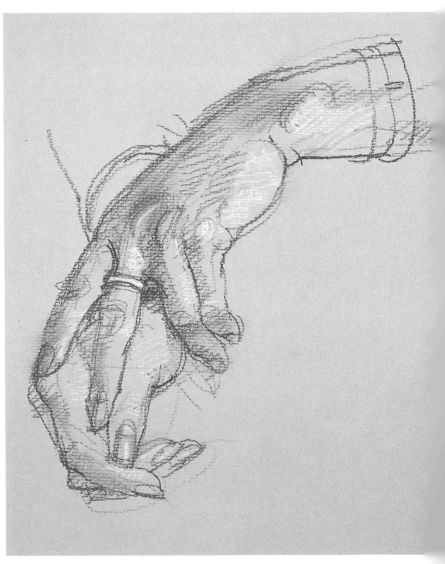

▲ **3** Continue to work up the details on the hands, using the white square pastel to add highlights.

▶ **4** Hands are amazingly complex subjects and many people find them difficult to draw. The trick is never to make assumptions about what you're looking at, but draw only what you see, starting by simplifying the forms.

The choice of materials here is perfect for the subject. The simplicity of the umber line and white highlights complement the familiar subject. This is an excellent choice of drawing tools for the beginner, since they force you to concentrate on the broad forms.

Portraits in hard pastels

Square Conté pastels are harder and chalkier than their soft counterparts. Their chiselled edges produce a quality of line that's most attractive and useful for many subjects, including portraits.

There are many brands of square pastels on the market, some harder than others (see pages 13–15). Conté pastels are particularly hard. They are available singly, in traditional sets of greys, black, white and earth tones, and in assorted colours.

You can sharpen them with a craft knife for line drawing, and hatch and cross-hatch with them to build up tones, smudging colours for blended effects. They are excellent for portraiture because of the amount of control they offer and their shape and texture give a great deal of versatility – you can make loose, sketchy and vigorous marks for bold effects, or soft and delicate ones for subtle results.

All these factors make them just as good for quick sketches as for fully explored and finished pieces of work. For quick studies, draw as many sketches as you can comfortably fit on a single sheet of paper, so you don't mentally cut away all your earlier work with each new sheet.

If you are aiming for a finished portrait, consider the composition carefully. Think about how to frame your sitter – where you want to place him or her, and how much space you want left around the figure. You don't want too small a figure (which looks lost), nor one that doesn't fit within the page.

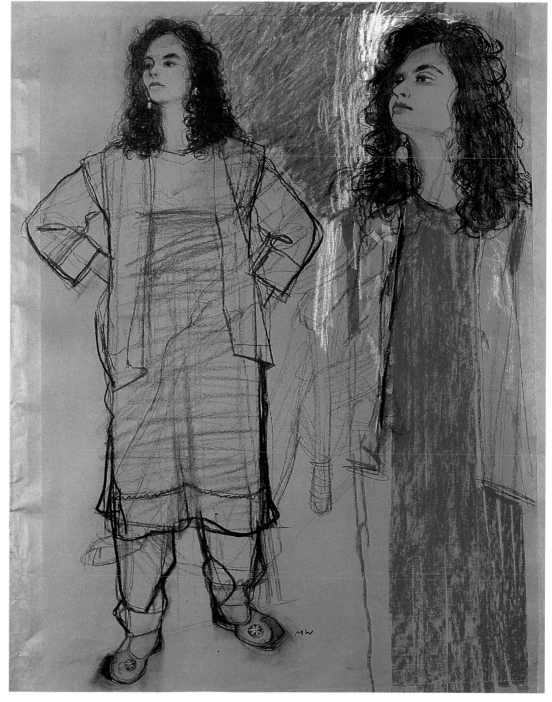

► In these studies a loose, sketchy approach and detailed, yet bold treatment combine to great effect. The model's face is vividly brought to life in both drawings with sensitive observation and a confident hand. Notice on the full figure the delicate highlight above the brow, rubbed away with an eraser to bring out the curving form of the skull beneath the skin.

Energetic marks on the body of the same figure keep the emphasis on the face through contrast, while the earrings emerging through a mass of dark curls bring a lively touch of colour.

'Lady in red' by Michael Whittlesea, pastel on paper, 70 x 53cm (27½ x 21in)

Leeann: three-quarter profile

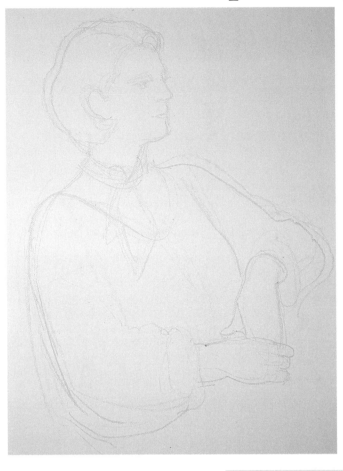

For this near three-quarter profile, the artist, Michael Whittlesea, started with an outline drawing, then built up some very delicate tones. He used colour as tone to describe form. As he progressed, he found the hair too dark and harsh. The remedy was to dust away the surplus marks and use the ghost image left behind as a guide to improving the portrait. This method, often called re-stating, is a good one to use for any study.

▶ **1** Make a careful drawing, pressing lightly with the pale blue pastel. Plan the composition so you frame the sitter within the confines of the paper. Where you want a fine line, on the outline of the forehead, say, draw with a sharp corner of the pastel.

Blue is a recessive colour, so it is often used for underpaintings, but in this case you'll strengthen the blue rather than lose it.

▼ **2** Start to strengthen your drawing, correcting it where necessary. Emphasize the facial features. Detail the curves inside the ear and draw in strands of hair.

Think about the relationship between the corners of the mouth, the nose and the inner and outer points of the eyes, or the portrait won't work. Keep redrawing the facial features until you are happy with them.

▼ **3** Bring on the facial features with mid blue. Use it also to work up the hair – follow the strands as they curve round the head and behind the ear. Blend your marks for a strong, darker tone above the nape.

Make sure the scarf outline appears to go around the neck. When you're happy with the scarf, erase superfluous lines to retain a subtle effect, then indicate its colour in creamy yellow and white.

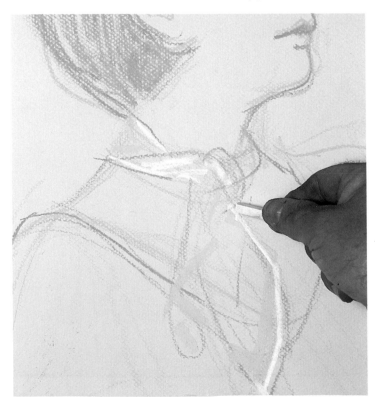

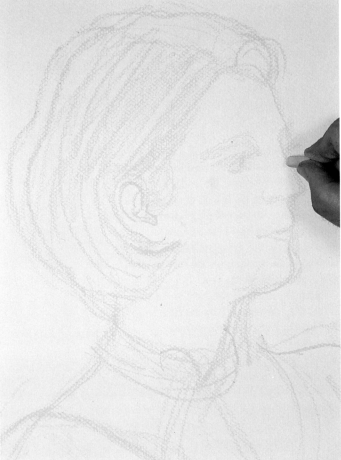

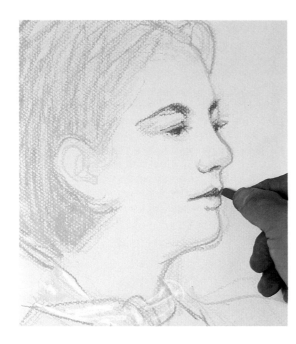

◄4 Erase any smudges around the profile, then switch to dark blue for the darker tones of the face. Sharpen the pastel tip or use a sharp corner to touch in the fine details of the eyebrows, the edges of the eyelids, the pupils and lashes. Notice how the three blues in the eye area work together to convey the turn of the eye socket. Stay with the dark blue for the curve and recess of the nostril, the outline of the lower lip and to block in the upper lip, which is in shadow.

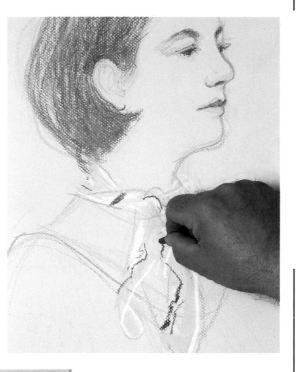

◄5 Fill in the lower lip with pale blue. Go back to dark blue to put in more strands of hair, smudging them for the darkest tones to build up more volume. Tidy up the hair around the nape of the neck with dark blue and outline the ear with the same colour.

Use dark blue to add a lively touch of patterning to the scarf. The artist strayed from the actual pattern of the scarf, giving these stronger marks a feeling of spontaneity rather than absolute accuracy.

▼6 Use the grey sparingly to indicate the pupils and lashes.

Now indicate the background. Because the back of the head is dark in tone, scribble around it with white to push it forward in space. The profile was strengthened with mid blue, so scribble in the background behind it with pale blue. By drawing around the head in this way, you define its shape further. The tones on the figure are quite subtle, so you can afford to scribble in the background quite energetically.

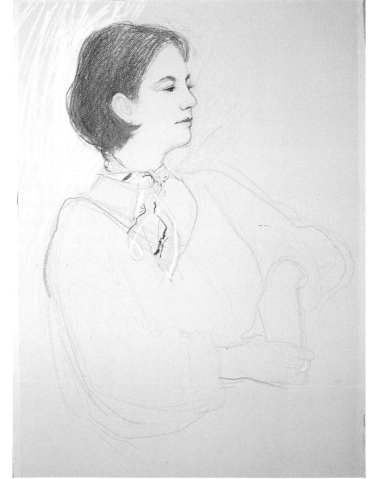

▼7 On assessing the drawing, the artist decided that the mass of hair seemed too solid, and didn't give enough of a feeling of the skull under the skin. It was also too dark against the rest of the figure, particularly the profile. He dusted away the marks on the hair with a soft rag, leaving a ghost image which would help him when it came to redrawing.

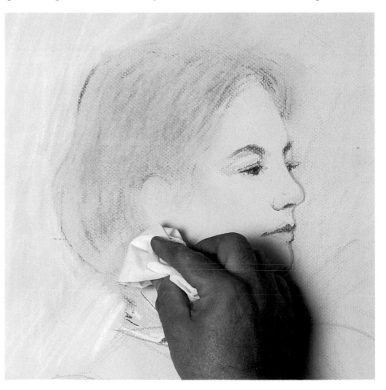

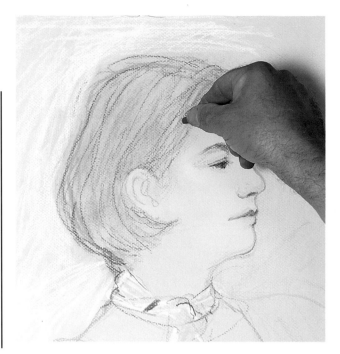

◄8 If you need to make any adjustments, dust off the offending marks as the artist did in step 7, then redraw them – here the artist is using dark and mid blues to re-state the hair, leaving the whole mass much lighter than before. At the same time he aims to give more of an indication of the underlying form.

Add more scribbles of white above the head, making them horizontal to help keep the viewer's eye within the picture area (vertical lines alone would lead the eye straight up and out of the drawing).

►9 By reducing the intensity of the hair tone, the lines and tones around the rest of the drawing seem stronger, creating balance in the composition. The profile, for instance, emerges more clearly as the focal point of the portrait.

Using the Conté pastels sparingly and sensitively in this way, the artist has subtly captured a sense of the elegant, rather majestic pose of his sitter.

Tip

Basic tones
Pastel enables you to create an image very quickly and with limited materials. For this picture the artist chose a warm, creamy coloured paper which provides a good skin tone. Then he used blue and white pastels over this to suggest tones, and almost immediately a convincing portrait began to emerge.

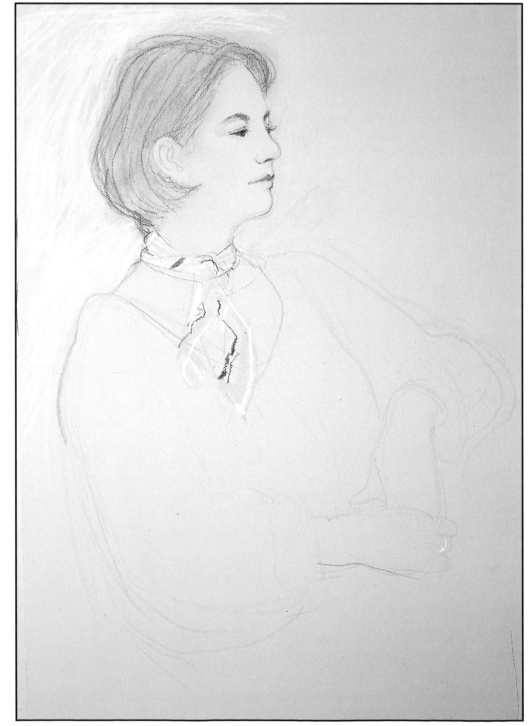

Alistair: head and shoulders

Working quickly, you can create dynamic results with energetic hatching, cross-hatching and scribbling for a range of tones, and free, undulating strokes for outlines. The facial features need a slightly more delicate touch if you want a good likeness. This is altogether a looser, freer rendering than the previous portrait.

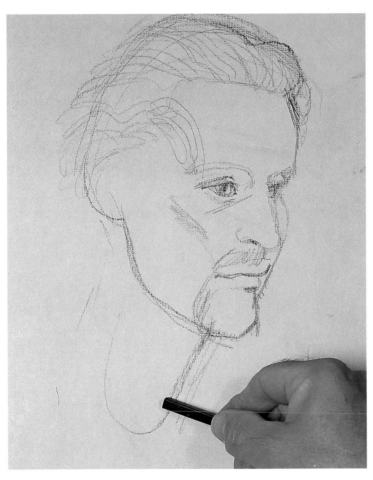

◀ **1** Start with an outline drawing in black pastel. Establish the forehead and sweep in the hairline so it travels round the cranium. Use the strands of hair to convey the skull's form. Put in the facial features and use the beard and eyebrows to show form. Follow the jaw to the ear and neck. Dash in shadows around the eyes and cheek.

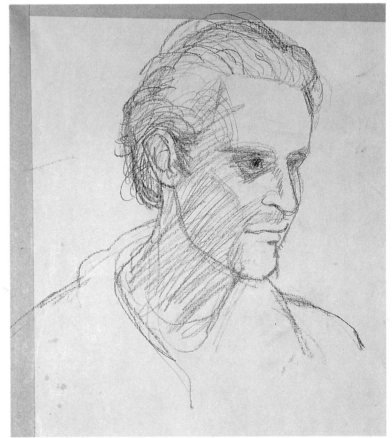

▲ **2** Continue down from the neck to establish the shoulders and neckline of the shirt. Chisel the planes of the face, starting on the cheek and neck with a loosely hatched tone. Develop the brows, then gently hatch in the shadows around the nose and eyes before darkening the pupils. Draw the curves of the ear. Now build up volume in the hair with varying strokes – some loose and wispy, others bold and thick.

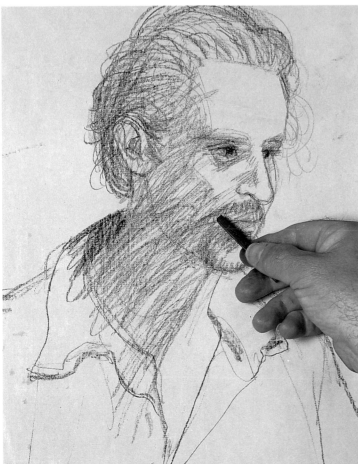

◀ **3** Working down from the neckline, draw the collar, the shirt front and the outline of the sitter's left arm. Build up the hair and place the shadow inside the ear. Bring out the moustache and beard, making sure your pastel strokes follow the direction of the hair growth.

Now put in the shadow on the back of the collar, applying more pressure for a darker tone. To balance these new tonal areas, darken the pupils further – these are the darkest areas in the whole portrait.

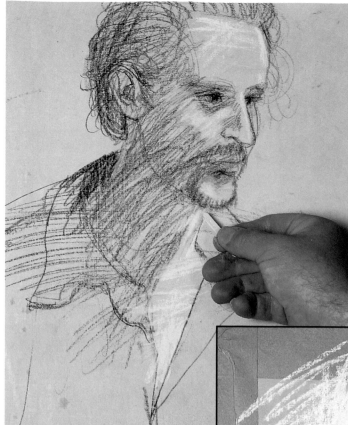

◄ 4 The light strikes the figure from his left – highlight these areas with strokes of creamy yellow across the forehead, cheekbone, nose, chin and down into the V of the collar. This new colour also helps to indicate something of the warmth of the skin tone.

Now balance these highlights by loosely hatching in a shadow across the subject's right shoulder with black, using slightly curved lines to indicate its shape.

▶ 5 Stretch out your arm to put in the background to the left behind the head. Use the white pastel, varying the pressure and cross-hatching and scribbling loosely to obtain a broken, varied tone. As in the previous picture, this helps to bring the head forward. Finally, touch in the whites of the eyes with the grey pastel. This bluish grey hints at the colour of the eyes.

The final picture is a good likeness of the sitter and captures his relaxed mood. Notice how the judicious use of colour – on the skin and eyes – helps to focus attention on the face.

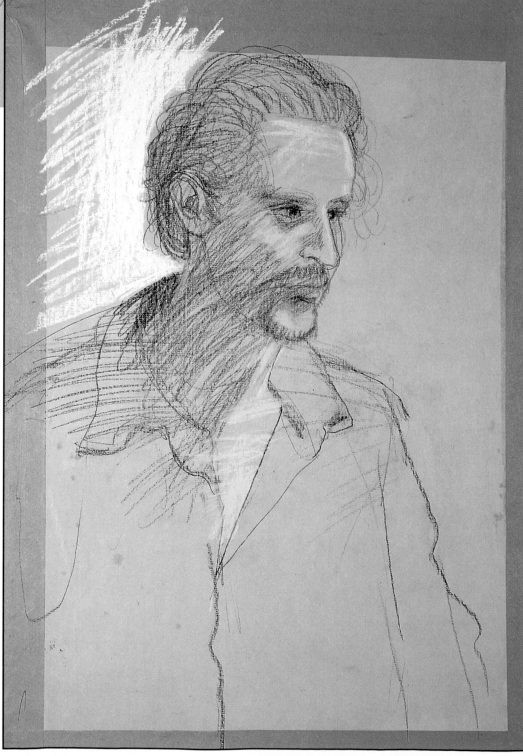

Using pastel pencils

Pastel pencils – soft pastels encased in wood – are an extremely versatile drawing medium. You can use them for filling in large areas of colour or, with sharpened tips, for precision drawing.

If you like the crumbly texture of soft pastels but wish to add a lot of detail to your drawings, then pastel pencils are just the medium for you. Clean and easy to work with, they are perfect for making the delicate colour gradations needed in portraits. Like pastels, the pencils work best on a slightly toothy paper; to prevent smudging, you must fix the finished drawing.

Mixing colours

There are several ways to mix colours with pastel pencils. For instance, you can blend two or more with a torchon or your finger, overlay two thin veil-like layers of colour or hatch and cross-hatch. But beware – as with pastel sticks, if you apply too many layers of colour, the tooth of the paper becomes clogged.

Pastel pencils are available in a large range of colours and tones to help artists find the right colour easily. For example, you can buy not only a bright yellow but also its pale and dark versions. This reduces the risk of clogging the surface unnecessarily by having to mix the bright yellow with white or black to achieve another tone. Each manufacturer produces a different number of colours. For more information enquire in your local art shop.

Blending bands of colour

▲ Use your fingertip to blend two large bands of colour quickly and easily. Don't press hard – all you need is a light touch.

▲ Try the very tip of a torchon for blending fine lines and small local patches of colour. Use the side for larger areas.

▲ You can make your own torchon by wrapping tissue paper around the handle of a paint brush.

▲ Cotton buds are handy for subtle blending as well as for lifting excess colour off your paper.

Portrait of two sisters

The set-up Like all children, the little girls posing for this portrait would have found it difficult to keep still for the duration of the work. When drawing and painting children, take several colour photos (see far right) to use for reference.

► **1** First make a lead pencil drawing of both girls to establish the basic features and tones. Trace the image from the pencil drawing with a red brown 7 pencil. (You can't use the pencil drawing as the first stage because the black lines will smudge, affecting the delicate flesh-tone colours.)

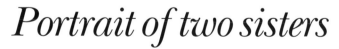

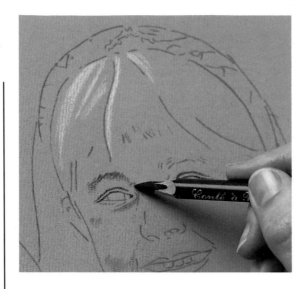

YOU WILL NEED

- A 30.5 x 45.75cm (12 x 18in) sheet of beige pastel paper
- Tissue paper and tape
- Lead pencil
- Torchon
- Cotton buds
- Paint brush
- Sandpaper block
- Fixative
- Conté pastel pencils (or their equivalent) in the following colours: bistre 1, dark green 2, red 3, red brown 7, pink 11, orange 12, white 13, gold yellow 14, yellow ochre 17, natural sienna 18, light grey 20, lilac 26, dark red brown 31, umber 32, garnet red 39, red lead 40, sepia 42, yellow green 44, Naples yellow 47, pale peach 48, light orange 49, slate blue 53, raw umber 54 and pale blue 56

◄ **2** Gradually build up the features of the elder girl, starting with the lightest and darkest tones. Use white 13 for highlights in her hair but change to sepia 42 for her eyebrows and the shadows of her face.

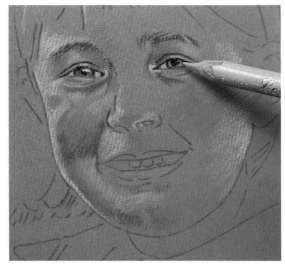

► **3** Block in the main flesh colours with light, feathery strokes. Subtle patches or planes of colour make up the face. You can pick these out by looking at the subject with half-closed eyes.

Shaded areas are cooler and contain more blues, greys, purples and browns (20, 26, 31, 53, 54 and 56). But where the light falls on the face the colours are warmer and contain more pinks, oranges and yellows (48, 49, 12, 11, 18, 7, 47 and 39). Draw the iris of the eyes in slate blue 53 and pale blue 56.

► **4** Use umber 32 to add detail to the nose and nostrils. Emphasize the dark shadows beneath the hair using the sepia 42 pastel. Draw in the mouth with dark red brown 31, and fill it with pink 11, garnet red 39 and red lead 40.

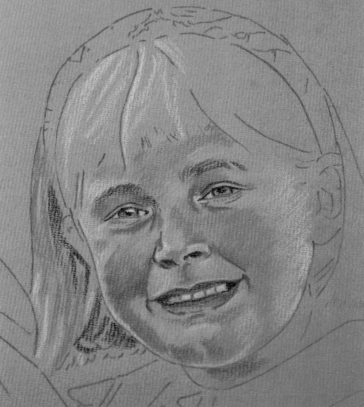

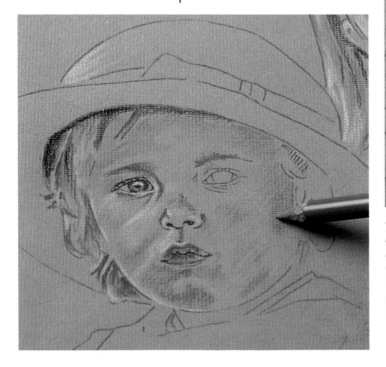

◄ **5** For the toddler, start by establishing the extreme lights and darks before blocking in the flesh tones. Use a sandpaper block to keep the pencil points sharp; otherwise your drawing will start to look blurred and indistinct.

The mouth, eye and flesh colours of the toddler are similar colours to those of her sister. Use sepia 42 for the shadow cast by the child's hat, and natural sienna 18 for the warm reflection on the side of the face.

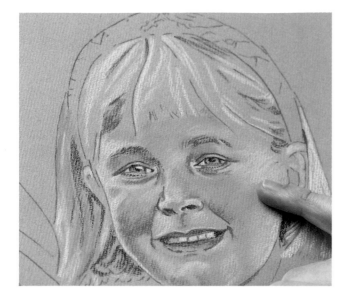

6 To blend the cheek colours together, gently rub the surface of the drawing with your finger. Remember, be restrained! A tiny patch of blended colour is more effective than a large area.

Pastel pencils are soft and wear down quickly – especially if you use them on coarse paper. Take extra care when sharpening them because the soft pastel core can easily crumble, so use a sharp craft knife to remove the wood carefully. Keep the tip pointed between sharpening sessions by using a sandpaper block.

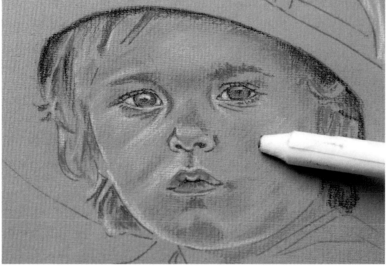

7 For lighter, more controlled blending, use a torchon. With the broad side of the point you can smooth large areas of colour; for finer blending use the tip of the torchon.

8 Before moving on to the clothes, stand back and take a good look at the portrait. Certain colours and tones need strengthening to compensate for the softening effect of the blending. For example, apply umber 32 to re-define the chin and neckline. Use pink 11 to add warm tones under the eye. Add bistre 1, gold yellow 14 and yellow ochre 17 to the hair of the elder sister.

When you are happy with the faces, block in the hat with two tones of blue and then the top left of the hat with white.

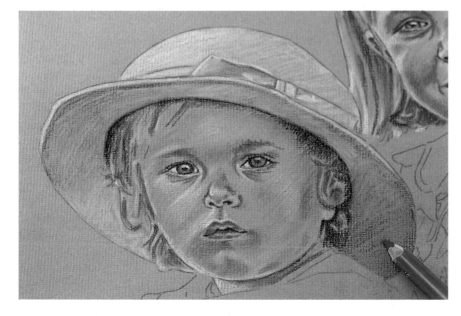

9 Where possible, keep the pencil strokes even and systematic. Even when drawing round forms and shapes, such as the girls' faces and the hat, you will get a more precise effect if you apply the colour in close, parallel strokes instead of trying to follow the curved form of the subject.

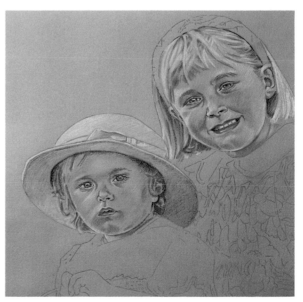

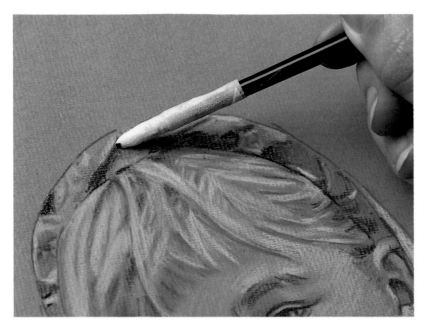

◀ **10** Fill in the patterned headband with white 13, dark green 2, yellow green 44, red 3, pink 11 and garnet red 39.

The artist made a very fine blender by taping tissue round the handle of a paint brush. Use it to smooth the tiny coloured patterns of the headband.

See how the artist's hand is not resting on any part of the portrait but off to the side to avoid any chance of smudging the colours.

▲ **11** Turn your attention to the toddler's dress, but resist the temptation to overdo the clothing.

Shade her arm with red brown 7, then soften the strokes with a cotton bud to suggest the smooth texture of skin.

▶ **12** Remember to spray fixative over the entire area at least twice. The finished portrait of two sisters is life-like, but not ornate and overworked.

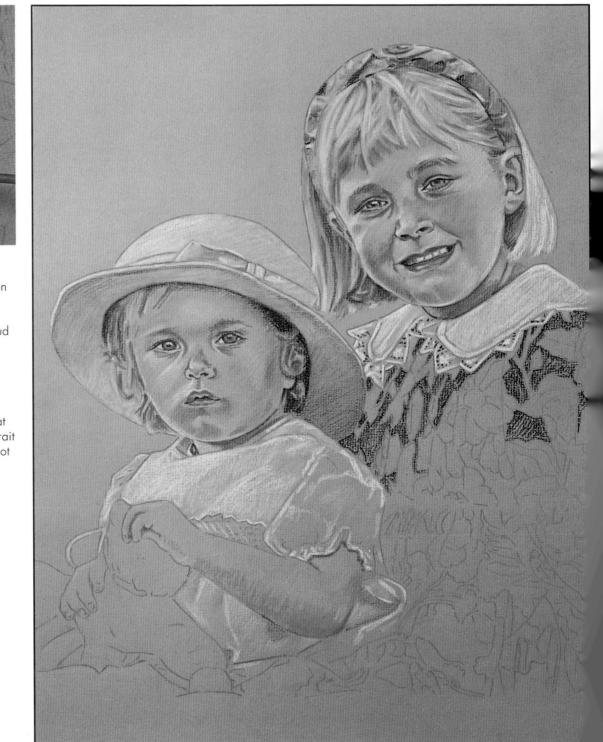

Introduction to oil pastels

Although they are a drawing medium, oil pastels give buttery, dense marks that are close to oil paint effects. Use them by themselves for bright and bold pictures or to great effect with various other media.

Oil pastels differ from soft pastels in that they are bound with oil and some wax as well (not gum or resin), which makes them dense and greasy. In general they make broad marks which are suited to large-scale work, but for finer detail you can sharpen them with a knife.

Typically, a set of oil pastels comes in intense colours, with rather less variation than soft pastels. They are often considered best for producing immediate impressions – rather than highly finished works with subtle gradations of tone. The bold colours are particularly good for stippling – juxtaposing dots of colour which, when seen from a distance, seem to merge into a sparkling, coherent surface.

One big advantage of oil pastels is that they don't break or crumble readily. This makes them relatively easy to transport, and therefore ideal for outdoor sketching in colour. Moreover, unlike powdery soft pastels, you don't need to fix your drawing.

Oil pastels can be applied with many other media. They are often used with oil paints – both for preparatory sketching, and also for adding final details or textures. Obviously, though, it's hard to use them on a painting that has a very rough, textured surface.

Another common application is as a resist. The oil base repels water-based media such as ink, gouache and watercolour, so that you can create bright highlights. With lightweight marks, some of the water-based medium clings to the oil pastel and produces interesting colours and textures.

The water-resistant nature of oil pastel also enables you to make an interesting scratchboard.

You simply wash ink or watercolour on to a stiff ground and, once this is dry, work over it with oil pastel in a different colour. The next stage is to use a hard-edged tool to draw with, scraping back through the pastel to reveal the watercolour, a technique known as sgraffito. (Make sure, though, that you don't scratch into the water-based undercoat.)

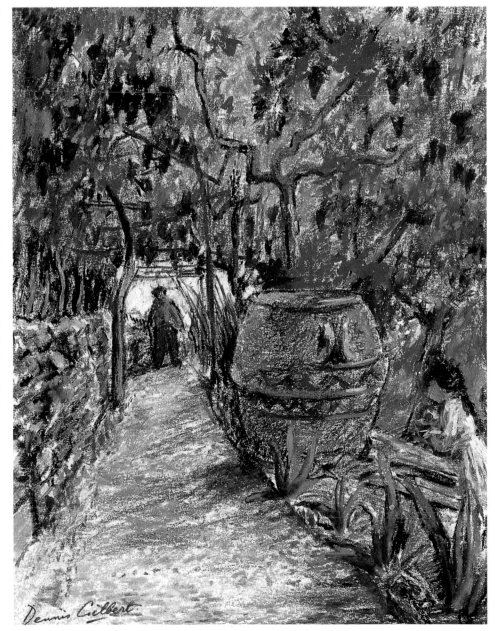

▶ **Oil pastel proved the ideal medium for this rather impressionistic garden scene. Smudging the dense marks of the oil pastels into one another brings the thick and tangled foliage to life.**
'Garden in Fiesole' by Dennis Gilbert, oil pastel on paper, 33 x 25.5cm (13 x 10in)

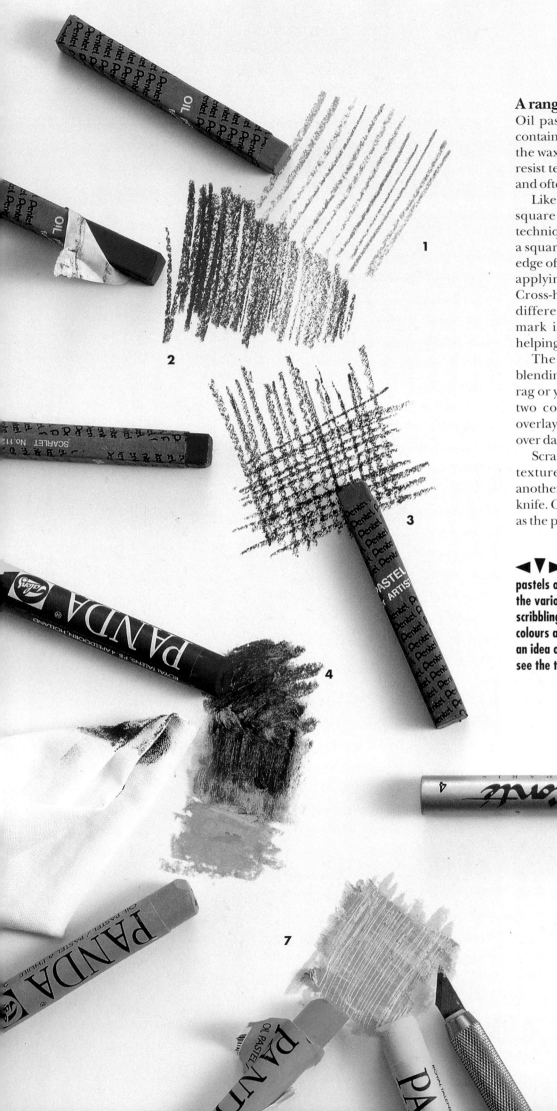

A range of marks

Oil pastels come in a variety of makes, each containing different amounts of wax. The higher the wax content, the more suitable they are for resist techniques. Those with less wax are softer and often considered better for general drawing.

Like other pastels, oil pastels also come in both square and round form. For most shading techniques, such as hatching (1), use the edge of a square pastel. For an even gradation, use the edge of a square pastel in close strokes, gradually applying less pressure to lighten the tone (2). Cross-hatching can be very effective in two different colours (3). Some of the underlying mark is often dragged into the top strokes, helping to blend the colours.

The buttery nature of oil pastel helps in dry blending techniques (4). Using a cotton or linen rag or your fingertips are a good ways to merge two colours. Colours can also be mixed by overlaying pastel marks. Experiment with light over dark (5) and dark over light (6).

Scratching out colour creates very interesting textures (7). Simply lay one colour on top of another and scrape off the top colour with a craft knife. Generally you scrape in the same direction as the pastel strokes, giving a sense of movement.

◄▼► Here are just a few of the oil pastels on the market and some examples of the various effects you can achieve with them: scribbling, hatching, scraping, overlaying colours and blending. The samples also give you an idea of a few colour mixes. For more details, see the text above and on the next page.

Be careful not to scratch into the paper surface – it's hard to disguise damage in pastel work.

One of the most creative techniques in oil pastel involves using turps to spread colours. With a brush dipped in turps, you can stroke out a single colour (8) or blend two colours – much as you would mix paints on a palette (9). You can also use the wooden end of a brush (10) or a rag to blend the colours. You might also try wetting the surface of the support first with turps and then applying the pastels. Always test the mix of your colours off your picture first.

White pastel changes the tone of a coloured one. Laying a colour on top of white 'knocks back' that colour (11). Applying white on top of a colour, on the other hand, suggests light catching the surface of an object (12).

Selecting your support

With oil pastels, you need a pretty robust ground. Use a stiff pastel paper, Manila wrapping paper, a canvas board or a piece of mount board. Thin pastel papers don't support the thick marks left by oil pastel. In a sketchbook with thin leaves, oil pastels stain through to the next page.

When diluting your pastels with turps, use a canvas board support. Stretched canvas isn't ideal since you can't press down hard enough to make bold marks.

Vase of sunflowers

YOU WILL NEED

- ☐ A sheet of 50 x 50cm (19¾ x 19¾in) cream mount board
- ☐ A drawing board
- ☐ A 2B pencil
- ☐ A set of oil pastels in the following 26 colours: deep chrome yellow, yellow ochre, lemon yellow, flesh pink, olive brown, olive green, light blue, light green, dark blue green, dark green, brilliant green, moss green, red brown, sepia, dark brown, burnt umber, raw sienna, burnt sienna, Prussian blue, blue violet, brown grey, dark grey, blue grey, yellow grey, light grey and white

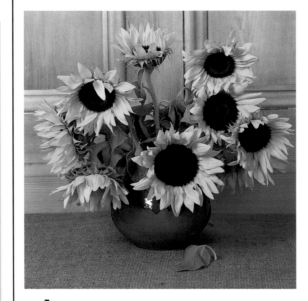

The dense, buttery marks characteristic of oil pastels are perfectly suited to the rich colours of sunflowers. The artist, Brian Busselle, worked intuitively, blending in layers of colour to capture the deep hues. He concentrated on the flowers, overlaying browns, greens and blues to capture the dark centres and putting down layers of yellow for the petals, using his fingers to blend in the colour and suggest a smooth surface. He then outlined the petals in dark green so the flowers jump forward from the rest of the picture.

◀ **The set-up** The artist chose the classic subject matter of sunflowers for his drawing. The light brown of the door and the matting provided a neutral background which complements the natural theme and the colours of the flowers and vase.

▶ **1** Use a 2B pencil to sketch the basic shape of the vase and sunflowers as well as the panels on the door in the background. Hatch in the foliage, loosely applying olive brown.

Use the tip of the lemon yellow to start the petals, then hatch in the pot in burnt sienna. Scribble in the flower centres in dark brown – allow the support to show through since this will be worked up in many different colours. Lightly apply the brown grey with the side of a pastel for the background door.

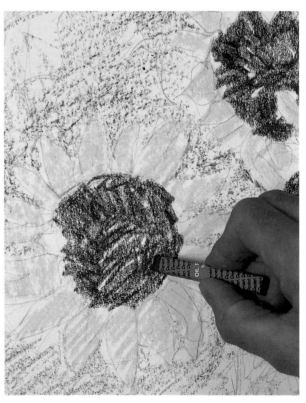

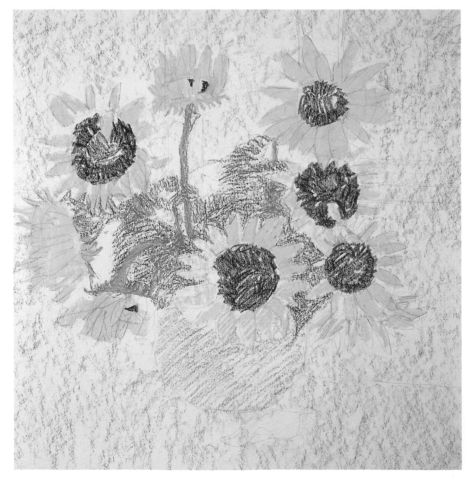

◀ **2** Use the tip of the dark blue green to build up the foliage. Add a few patches of light blue for the highlights. Continuing with the light blue, draw in the sepals and stems. Then overlay this with light green and lemon yellow. Also use the lemon yellow to build the intensity of some of the petals, always working away from the centre.

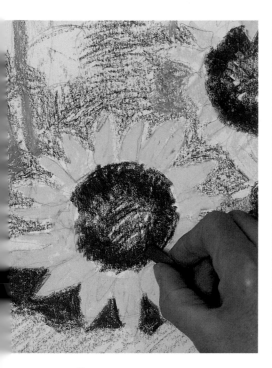

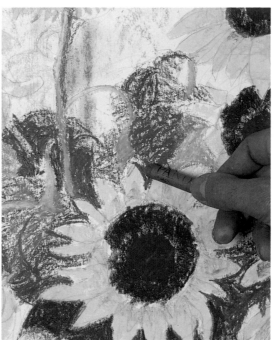

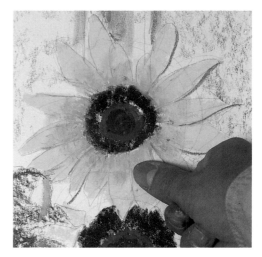

▲ **3** Add more lemon yellow to deepen the colour of the inner parts of the petals. Block in the top of the pot with red brown and apply sepia to the dark outer rim of the sunflower centres to show form.

▲ **4** Use moss green to fill in the central eye of the sunflowers. Continue adding light blue, light green and lemon yellow to the paler parts of the foliage. Work over this with white to suggest light catching the leaves and stems. Redefine the shape of some of the leaves with dark green.

▲ **5** Use the side of the yellow grey pastel to indicate the moulding on the door. Soften these lines with the tip of your finger so the moulding is distinguished in texture from the panelling.

Add a little deep chrome yellow to the base of the petals. Smudge this into the paler yellow with your thumb or finger to indicate a slight curve to the petal. Use olive green to describe a lighter ring in the centre of the sunflowers.

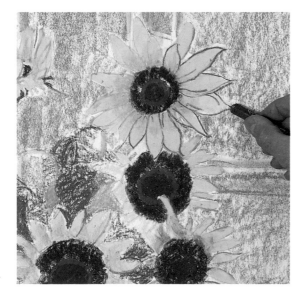

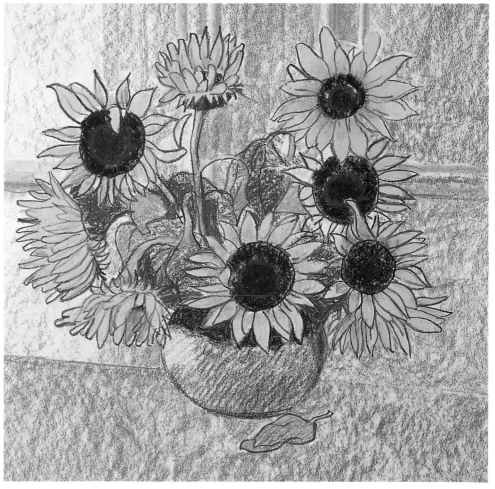

▲▶ **6** Draw in the fallen leaf with light blue and a little dark green. Use the tips of the burnt umber and red brown to build up the glaze on the vase (right). With the side of the yellow grey pastel, darken the background. This brings forward the yellow in the sunflower petals.

To draw the whole plant out from the background, use the dark green pastel to outline the shapes of the petals and the foliage (above). If you smudge this outline later, you can correct it by scraping with a palette knife.

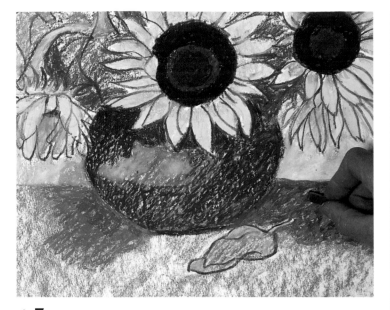

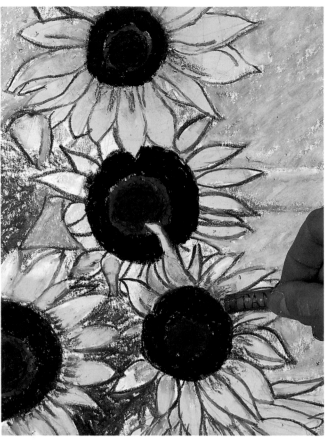

▲**7** Use a few dashes of blue violet on the outer ring in the central part of the sunflowers. Go over this with burnt umber and sepia, allowing some of the blue violet to show through. Fill in the centre of the sunflower with some moss green and Prussian blue.

Emphasize the base of the pot with raw and burnt sienna. Leave a patch of highlight showing through, and add flesh pink to this. Tone down the whole area with light grey. Using bold, sketchy strokes, draw the shadow of the vase in dark grey and blue grey.

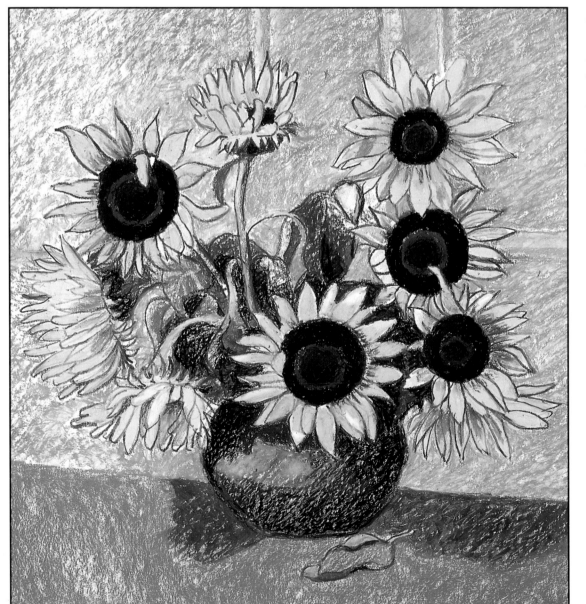

▲**8** Add some small lines radiating from the base of the petals in burnt sienna. Soften these by overlaying with yellow ochre. Also sparingly add small strokes of olive green on a few of the petals.

Build up the foliage, using moss green around the petals and Prussian blue to fill in the deeper shadows. Also use Prussian blue to outline the base of the pot. Go over the door with blue grey.

◀**9** As a finishing touch add brilliant green on the fallen leaf and sparingly on the darker foliage on the plant. Then give the floor some more body by applying yellow grey.

In the final picture you can see how the artist has put his pastels to good use with just a simple scribbling technique. He has kept the wall, floor, vase and leaves fairly sketchy so that the more solid colours on the flowerheads demand – and receive – more attention.

Choosing pastel papers

Pastels are such attractive things they cry out to be picked up and used. But before you start drawing, make sure you have special pastel paper – it's essential for good results.

When you first start pastel drawing, it's tempting to practise on any piece of paper, even scrap. You'll move on to the proper stuff when you've perfected the technique, you say to yourself. But nothing could be more misguided. Right from the start you should draw on the correct support – pastels simply don't work on certain surfaces, giving disappointing results when you use them.

Supports made for pastels have a textured surface designed to hold the tiny crumbs of colour. This surface allows you to build up several layers of pastel, filling the holes until they can't take any more. Boards and papers with no 'tooth' are no good – pastels don't adhere to them.

The right colour
Pastel papers come in such a vast selection of colours that it can be bewildering at first knowing which to choose. Naturally the choice of paper is up to you, but remember that it does always affect the finished

picture. Here are four rough rules of thumb to bear in mind.

● Go for pastel paper that contrasts with the subject's colours, not one that harmonizes with them. For instance, a brightly coloured flower arrangement might look good if you did it against a muted, neutral background. And a mainly green landscape would be well set off by using a red or brown paper.

● On the other hand, use the tint of the paper in a positive way to emphasize similar colours in the drawing. Sticking with the flower arrangement, a blue paper would draw out the blues of the flowers, while red would accentuate the reds.

● Whatever colour paper you finally plump for, it's best to work on a mid tone. With a tone that is neither very pale nor very dark, both light and dark pastels show up well.

● Unless you specifically want a white background, it's almost always a mistake to work on white paper. You end up spending a lot of time scribbling to get rid of the white, and the result is generally fuzzy and less effective than if you had chosen a toned paper in the first place.

▼ **Special pastel papers have a rough texture designed to hold plenty of pigment. They come in a vast range of colours, offering the artist every chance to use the best one for each drawing.**

Types of pastel paper

Pastel papers don't just differ in colour – they also differ in tooth. The leading names in the field are Canson and Fabriano, with their Mi-teintes (say *My-tahnt*) and Ingres (say *Ang-rer*) ranges.

Both Mi-teintes and Ingres papers come in a large selection of colours and have a good, medium-textured surface. They are excellent all-purpose supports, but for different effects it's worth experimenting with some of the others.

Velour papers are velvety – just like flock wallpaper – and produce a rich, matt finish more like a painting than a drawing. They're available in pads of different colours and also come as single sheets, though these can be hard to find.

Sansfix papers are rather like felt or extremely fine sandpaper. Because their tooth is quite fine, they hold plenty of colour, giving the same kind of finished effect as velour papers. They come in a limited range of neutral tones and, as their name suggests, don't have to be fixed.

Sandpaper is a serious alternative to sansfix paper. It must be the finest quality stuff, though – coarser grades wear pastels away rapidly. Buy it from your local hardware store, where it is often called flour paper. One disadvantage is that you may only find it in small sizes. Also, it may not be made with acid-free materials so could deteriorate; and you have to use fixative.

Cabinet paper is really only ordinary sandpaper, though it does come in good big sheets. You'll find it on sale in larger art shops.

You can also use watercolour paper for pastel drawing. You're better off with the tinted kind (pastels aren't easy on white backgrounds) – it should also be NOT rather than hot pressed, which is too smooth.

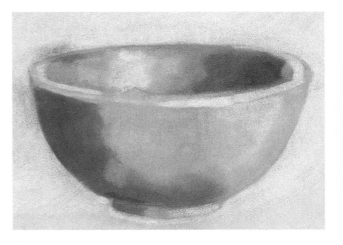

▲ Velour paper is rather more costly than Mi-teintes and Ingres papers, but gives an incomparable smoothness and sheen to a subject like this wooden bowl.

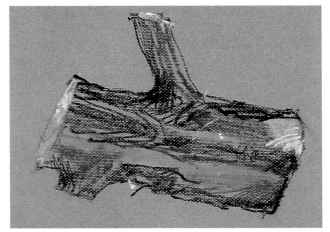

▲ Mi-teintes and Ingres papers are good for general use, but come into their own when you want 'broken' colour to convey texture, as with this rough tree bark.

Tip

Anti-clogging
If the surface of your pastel drawing becomes clogged with colour – which can happen all too easily with heavy-textured papers – don't despair! You can remove some of the surplus pigment by tapping the back of the support briskly. Don't overdo it, though, or you'll lose all your pigment.

Different papers, different tooths

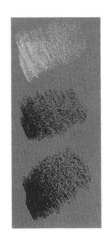

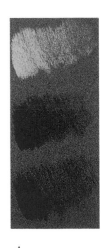

▲ Sandpaper ▲ Cabinet paper ▲ Mi-teintes paper ▲ Ingres paper ▲ Velour paper ▲ Sansfix paper

Three papers, one floribunda rose

To show the effect of different coloured pastel papers our artist, Sally Michel, drew the same simple image three times. One is shown below, drawn on the most muted and neutral of the papers. Overleaf you'll find two variations.

Before you start your own drawing, look carefully at the three finished pictures and decide for yourself which works best. Bear in mind that though the effects are quite different, the one you prefer is ultimately just a matter of personal taste.

One thing is clear, though – the colour of the support is all important. More than just a background, it contributes a great deal to the tones of the picture – as these flowerheads demonstrate beautifully.

▲ **The set-up** A freshly picked rose

YOU WILL NEED

☐ *A small sheet of Ingres or Mi-teintes pastel paper in the colour of your choice*

☐ *Box of 24 pastels including olive green, yellow green, viridian, terracotta, white, silver grey*

☐ *Spray fixative*

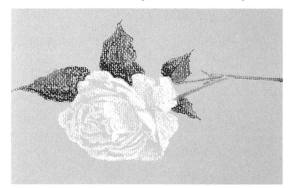

▲ **1** Spend a few minutes studying the rose. It's tempting to draw a series of concentric circles, but notice the way the petals grow out from the middle.

Lightly draw in the outline of the leaves with an olive green pastel. Then do the stems in yellow green with touches of viridian. Use terracotta for the thorn and flower base. Starting in the middle, sketch in the outline of the rose and its petals with a white pastel.

▲ **2** Now put in the brightest parts of the flower, shading them in with the tip of the white pastel. Decide where you want the darkest tones to be – you're using the bare paper for these – then put in some mid tones, covering the support more lightly than you did for the bright parts. Notice how the texture of the paper breaks up the colour of the pastel slightly.

Different coloured supports

When it comes to working on supports other than light grey, you might well want to draw with different pastels from the ones used here on this page. The artist chose to vary the colour of the rose, for instance. By selecting pale pink on the warm pink paper, and pale yellow on the beige paper, she was making a connection between the colour of the rose and the background – a device she also employed successfully when she did the shadows (see overleaf).

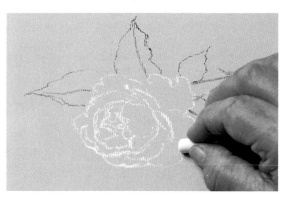

▲ **3** Draw in all the leaves, using yellow green for the lightest areas, viridian for the mid tones and olive green for the darkest parts. Again, notice that the tooth of the paper shows through clearly, breaking up the colour in an attractive way and providing some texture.

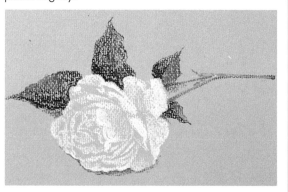

▲ **4** Now put in shadows so that the rose 'sits' on the surface. Don't use black. Provide a link with the paper by using a related tone – on this light grey the artist used silver grey. Draw shadows under the leaf on the left, both leaves on the right, the flower and under the stem. Fix the picture with fixative.

Grey, beige or pink

Drawn on three different paper colours, the same rose has ended up looking startlingly different. Which you prefer is entirely a matter of taste. Take your pick among the grey – the most neutral colour of all – the warm beige, and the almost 'hot' heathery pink. The same principles can be applied to any pastel drawing you are doing. Use a suitable colour and texture of paper for your subject and you won't go far wrong.

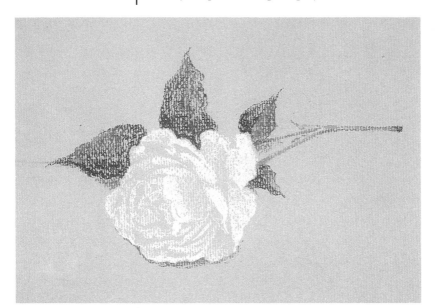

◄ The grey of this paper provides an excellent contrast to the subject matter and, because it's the most neutral colour in the drawing, it sits back, giving a good indication of space.

The final image looks crisp from a distance, even though the tooth of the paper showing through adds softness and subtlety to the rose petals.

▼Here, the colour of the rose is very close to that of the support, with the result that the flower can also be read as a negative or positive image, like the weave on a piece of damask cloth.

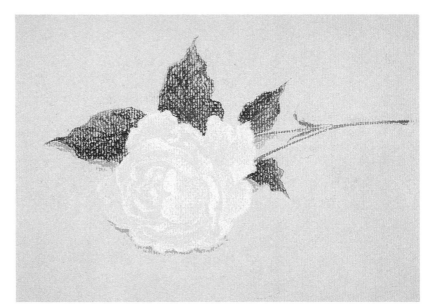

Tip

No-smudge drawing

A classic way of drawing with soft pastels and not smudging them at the same time is to work without resting your hand on the support. As you can imagine, this is a tricky business. One way round it is to lean on a small sheet of tissue paper or thin polythene.

► This rose has a lovely blush to it, caused by the tint of the paper showing through.

This 'hot' pink paper colour tends to 'advance' slightly, so you need to take care that it doesn't compete for attention with the flower itself.

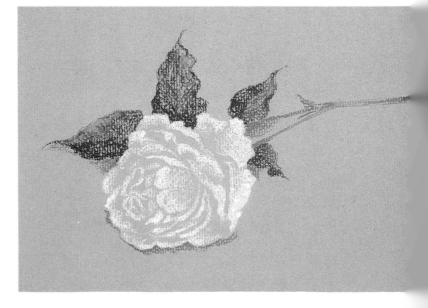

Using coloured paper

Just as pastel colours mix optically when they are placed next to each other, so they change when used on coloured papers. A strong paper colour can radically heighten the effect of your pastels.

With pastels, perhaps more than with any other drawing medium, the colour of the background paper plays a crucial role. Since pastels are applied dry and need to be used on paper with a toothed surface, there are always areas of the background left uncovered, so the colour shows through and mixes with the pastel tones. This makes your choice of support very important. You should select the colour of your paper bearing in mind the final effect – or range of effects – you want to achieve.

However, you can take the potential of coloured papers still further, using the papers as vital contexts, even dominant features, of your pastel drawings. In this case, deciding on paper colour can be tricky. If your subject is brightly coloured, you may want to give it an extra boost by using a bold paper. For instance, red pastel on green paper carries a fiery, 'signal' charge, while yellow pastel on dull red paper has an electric effect. Compare your subject's dominant colour with the other strong colours in your pastel box, and choose your paper colour on that basis.

For her pastel drawing of a girl in a pink sari, the artist, Kay Gallwey, chose a paper in a strong burnt orange colour. This ignites the pink of the model's sari and the red of the cloth she is sitting on; it also enriches the black of her hair. Large patches of the paper are left bare – even within the confines of the drawing – so the girl seems to emerge naturally from the glowing background. Think how muted the drawing would be if it had been done on plain white paper!

A glowing rendition
Fluorescent soft pastels are difficult to find because the colour is provided by a dye, not a pigment, and this dye is fugitive in soft pastels. However, you can add emphasis to your soft pastel drawings by mixing in a few fluorescent oil pastels. Alternatively just use brightly coloured soft pastels.

▲ Blue and orange are complementary colours, so the orange pastel really sings out on this blue paper. Notice, too, how bright the sweeping yellow highlight on the model's back looks against the dark of the paper.
'Kneeling girl' by Kay Young, pastel on blue-grey paper, 45 x 37.5cm (17¾ x 14¾in)

Girl in a pink sari

▼ **The set-up** This artist has travelled in India quite extensively, and loves the vibrant colours of the women's clothes. The pink material of the model's sari is translucent, so the yellow of her blouse and underskirt and the rich black of her hair is just visible beneath it.

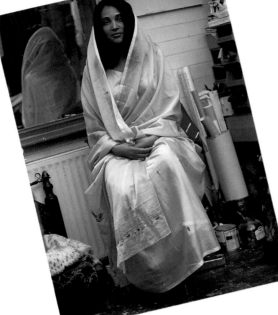

► **1** Indicate the position of the model and the planes of the sari. Use quick strokes of fluorescent pink/rose madder 2 for the edges and rose madder 0 for the highlights. The artist decided to draw the sari parting over the model's knees. She used lemon yellow 6 to show the underskirt and indicated feet and shadows in lamp black.

YOU WILL NEED

- ☐ A 75 x 54cm (29½ x 21½in) sheet of burnt orange Canford

- ☐ One navy blue wax crayon

- ☐ One fluorescent pink oil pastel (or use rose madder 2)

- ☐ Thirteen Rowney soft pastels: lemon yellow 6, Naples yellow 2, poppy red 8, rose madder 0 and 2, Prussian blue 5, olive green 2, cobalt blue 2, Vandyke brown 8, madder brown 2, sap green 3, lamp black and white

◄ **2** Scribble some shadows on the sari in cobalt blue 2 and olive green 2. Block in the cloth over the chair with poppy red 8 then go back to the lemon yellow to indicate the visible part of the blouse. Now put in the energetic folds of the sari with bold sweeps of rose madder 0.

▶ **3** Scrub on some Vandyke brown 8 to indicate the hair. Outline the face and indicate the eyes with madder brown 2. Use fluorescent pink to suggest the sari round the head with rose madder 0 for highlights.

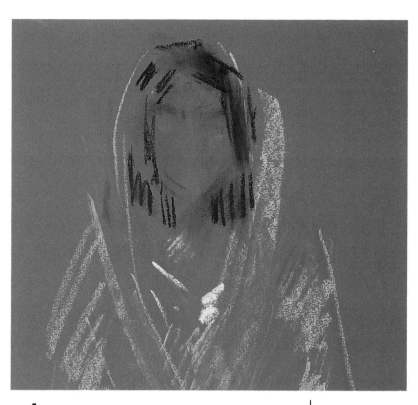

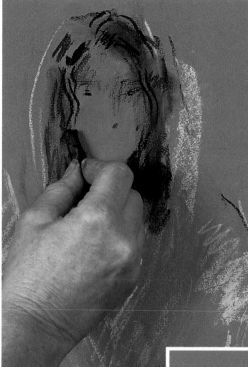

◀ **4** Use lamp black to set the position of some of the facial features and build up the hair with black and Prussian blue 5. Scribble in some lemon yellow on parts of the sari to indicate the blouse and underskirt showing through the fabric.

▶ **5** Carry on building up the colours of the sari, adding more rose madder 0 and lemon yellow. Use some of the lemon yellow on the red cloth to indicate its pattern.

The artist now decided not to show the sari parted over the knees after all, so she lightly wiped off the yellow of the underskirt. Feel free to make similar changes as you see fit. Work on the fabric folds and indicate the hands with the navy blue wax crayon.

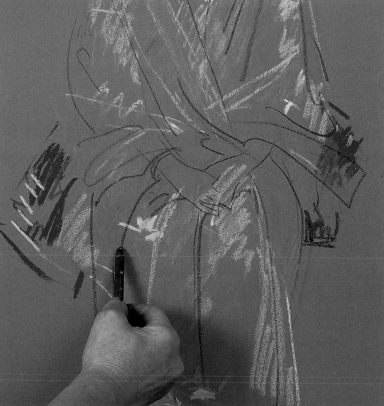

Tip

Pastel trays
Most regular users of pastels end up with a huge

assortment of short pieces. When this happens to you, sort the pieces into similar colours and keep them loose in shallow trays. In addition, put rice grains in the trays to keep the pastel pieces dry and clean.

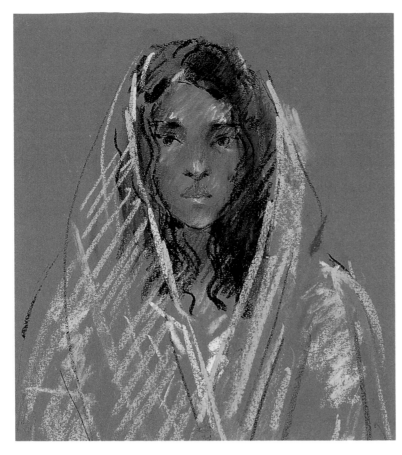

6 Hatch in the basic skin tone on the face and hands with sap green 3. Define the features of the face with lamp black, then use white to add the highlights.

Work into the hair with black and cobalt blue, and use the black to outline the sari where it goes over the model's head. Work on the sari with rose madder 0. Then colour the upper lip with rose madder 2 and highlight the lower lip with white.

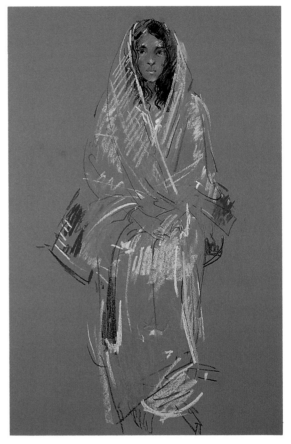

7 Continue adding a few dark tones and outlines with the navy blue wax crayon. Also use it to draw the areas of the chair which are visible. Then apply quick scribbles of rose madder 0 around the feet to indicate a covering of sari fabric.

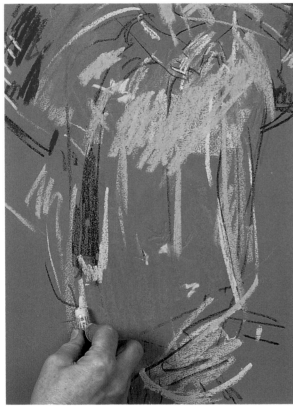

8 As you progress, continue to build up the tones on the sari with fluorescent pink/rose madder 2 and rose madder 0. Use Naples yellow 2 on the hands.

9 Build up the face with madder brown 2, Naples yellow 2 and white. Indicate the blouse and underskirt, seen through the sari fabric, with lemon yellow 6. Also work on the sari.

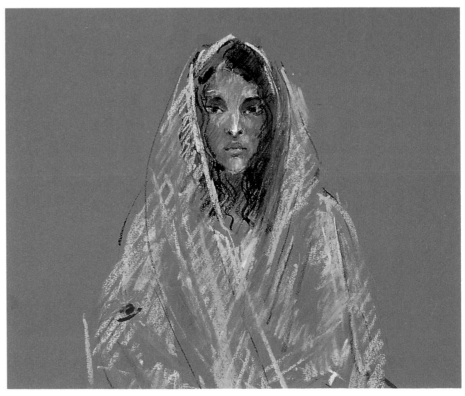

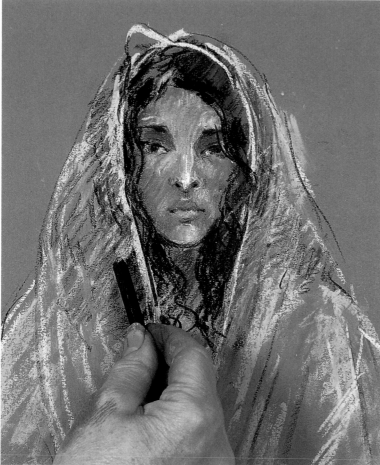

10 Pick out the irregular outline of the fabric around the face with rose madder 0 and lamp black. Use the black to suggest the hair seen through the translucent sari fabric.

11 Lightly use the tip of your little finger to smooth in the skin tones of the face. Sharpen up the features with lamp black – the eyes and eyebrows, the line of the mouth and the nostrils.

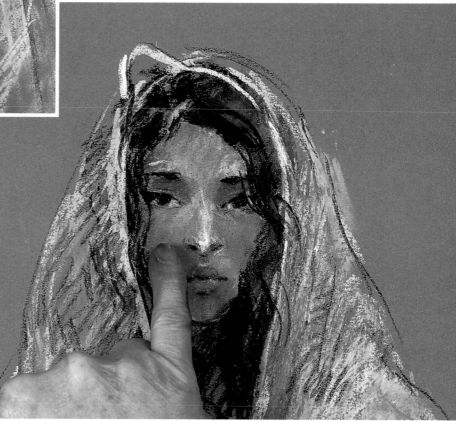

12 Add forceful diagonals of lemon yellow 6, cobalt blue 2 and poppy red 8 to render the hem pattern of the sari as it drapes over the model's feet. Accentuate the directions of the folds with more lines of navy blue crayon and with streaks of white here and there.

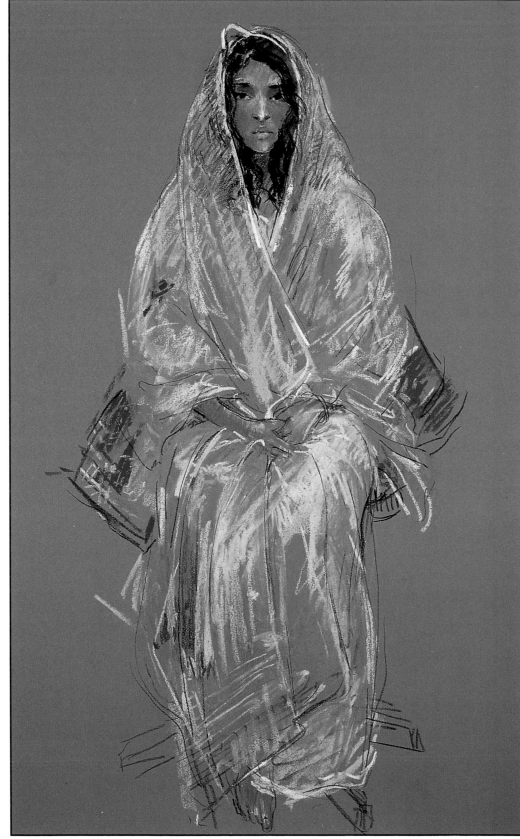

▲**13** The model's lap is a focal point – concentrate now on putting more detail there with sap green 3. Redefine the outlines of the hands and the fabric folds on the lap with navy blue crayon.

Smooth more Naples yellow 2 on to the back of the hands to render highlights. Add faint shadows around the hands with light touches of Prussian blue 5.

▲**14** The drawing is now finished. If necessary, add some last lines of white to emphasize the major folds of the sari, and make sure the black of the model's hair is rich and smooth where it is not covered by the sari, and sketchy where it is.

CHAPTER TWO

Creative pastel projects

Colour as a theme

The choice of objects for a still life can be so large that it becomes quite distressing trying to make a decision. One way to narrow the field is to work on a colour theme.

Selecting items of a single colour for a still life is a good way of creating unity between otherwise disparate objects, such as the plates and flowers in this demonstration. And it also creates a pleasing colour harmony.

It's a bold move to paint a picture solely in shades of one colour, so often artists choose a dominant colour – in this case blue – with one or two colour accents. You can choose whatever you like, but a little of the relevant complementary can bring out the true richness and depth of the dominant colour. Our artist, Jackie Simmonds, added yellow in the form of the pears – this is the complementary of the blue-violet hydrangeas and the purple grapes. However, you might decide to add a couple of oranges, since these would be complementary to the cobalt blue of the plates and fruit dish.

Nature added its own harmonious accent to the colour scheme by providing the blue-green leaves of the hydrangeas – this is known as an analogous harmony because the two colours (blue and green) are adjacent on the colour wheel. To balance this in the composition the artist added the limes, the green grapes and a green pot plant.

▲ **The set-up** Select a range of objects with a colour theme – our artist chose blue, offset with white, yellow and green. Supplement the natural light (here coming from a window on the left) with an electric light on the same side to give a warm glow.

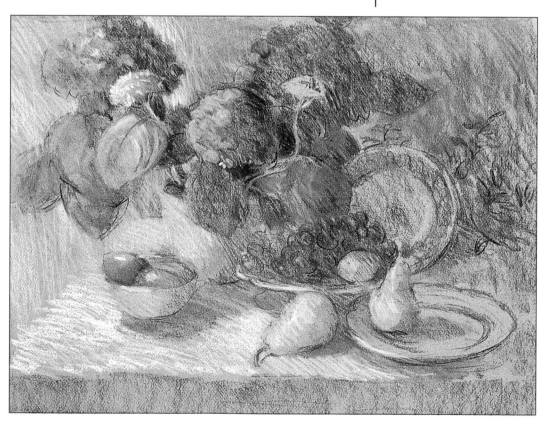

▶ It's always worth making a preliminary drawing of the set-up to get your eye in and to help you resolve any potential problems at an early stage. The artist used black and white soft pastels for a tonal sketch – this not only enabled her to look for and assess the shapes and positions of everything but also made it easier to see if the balance of tones worked compositionally.

YOU WILL NEED

- ☐ A 55 x 72cm (21¾ x 28¼in) sheet of pink-grey Canson paper
- ☐ A stick of fine charcoal
- ☐ A soft round watercolour brush
- ☐ Spray fixative
- ☐ Drawing board; easel
- ☐ Schmincke soft pastels (or their equivalent) in the following colours: mid and light sunproof lemon yellow, sunproof yellow deep, sunproof yellow light, ochre light, orange ochre, ultramarine deep, light and mid ultramarine pale, dark bluish green, dark, medium and light cobalt blue imitation, light and mid bluish violet, grey blue, dark, light and very light cold green, leaf green, olive green, moss green and May green

▲ Storing your pastels in groups of colours will stop the pigments tainting one another. It will also make the job of choosing colour themes for your pictures easier if you can see at a glance which hues you have in your collection.

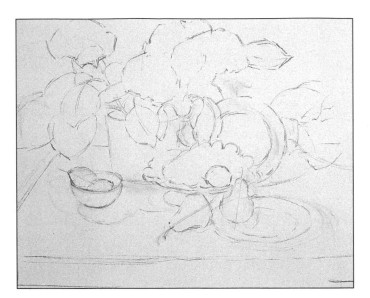

▶ 1 Working on the smoother side of the paper, lightly tick in the still-life group with the charcoal. Once you are satisfied with the positions of everything, spray the drawing with fixative to prevent the charcoal blending with the colours. Leave it to dry.

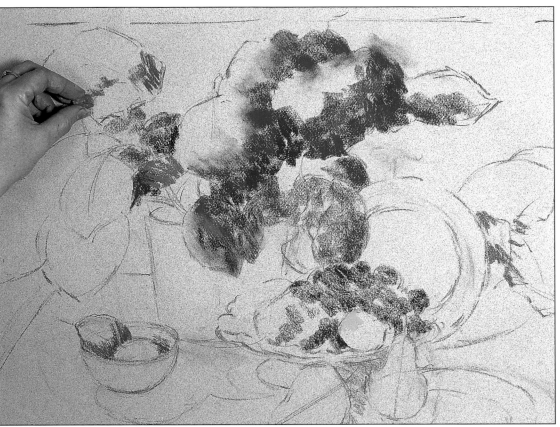

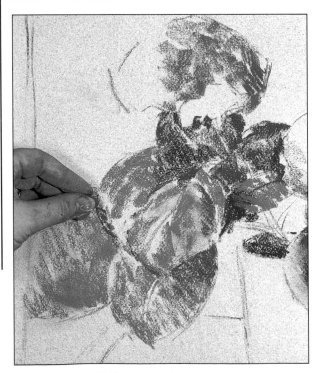

▲ 2 Snap off short pieces of pastel to block in some of the dark tones on the flower heads and grapes – use deep blues, applying the colour in side strokes with gentle pressure. Apply dark cold green for the leaves and add some mid tones to the flowers with medium cobalt blue.

◀ 3 Loosely block in the hydrangea leaves on the left with leaf green, using dark cold green for shadows and allowing the bare paper to stand for the highlights.

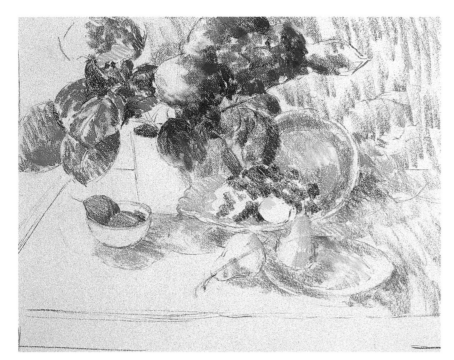

◀ **4** Continue feeling your way into the painting with light, exploratory marks, using the sides of the pastels. Don't concern yourself with detail but simply with locating forms and assessing approximate colours.

Look for subtle differences in colour, such as the bright white of the flowerpot compared with the greenish blue tinges on the white areas of the plates.

Define the shadow behind the group and the cast shadows on the table with loosely hatched side strokes of mid ultramarine pale and dark bluish green. Use the same colours on the plates, and also try warm greens on the plates.

▶ **5** Start to introduce warmer, lighter colours, applying broken strokes of the sunproof yellows and ochre light in areas lit by the warm glow from the lamp. This creates a warm 'pathway' which leads the eye into the picture and makes a lively contrast with the deeper, cooler blue tones.

Tip

Supermarket palette
A small plastic tray – the kind supermarket vegetables come in – makes a lightweight, easy-to-hold

'palette' for keeping the pastels you are using for your drawing. Line it with a paper tissue to prevent the dust from one pastel sullying another. You can also use these trays to store your pastels – group them according to colour.

◀ **6** Now that you have mapped out the broad shapes and tones of the set-up in your picture, start to build up details. Here the artist is blending and softening some of the colours with her finger so she can work over them with further strokes of pastel.

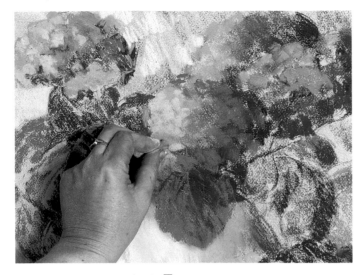

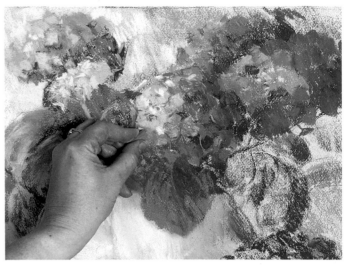

▲ **7** Start to model the hydrangea heads by putting in the basic mid colour with light cobalt blue. To do this, break off a short piece of pastel and press it flat on the paper, making short, blocky strokes which capture the shape of the petals. Angle the strokes to follow the curve of the blooms. Add highlights by working light ultramarine pale over the top. Use sunproof yellow light for the small, immature blooms.

▲ **8** Compare this stage with step 7 to see how the blooms are shaping up. Use tonal variations to give the flower heads form. Detail should be given to the hydrangeas but not so much that they lose their painterly quality. Add highlights to the immature blooms with linear strokes of mid sunproof lemon yellow. Bring the nearest hydrangea head forward by picking out the V-shaped edges of some petals with ultramarine deep.

▶ **9** Model the forms of the pears in the same way, applying overlaid strokes of May green, sunproof yellow light and mid sunproof lemon yellow. Touch in hints of moss green on the shadowed side of the pear on the right.

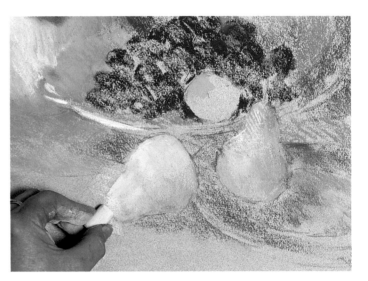

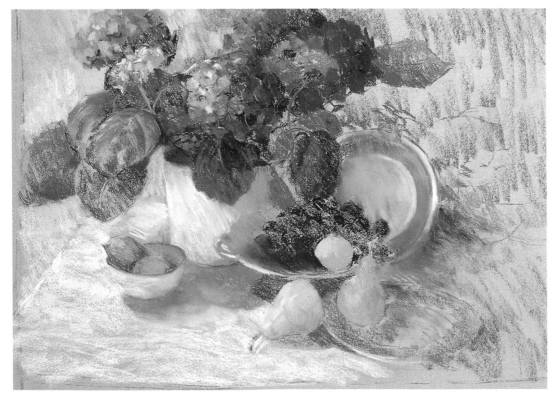

◀ **10** Keep working over the picture with small touches of colour, letting the image emerge gradually. As you work, keep an eye on the balance of colours and shapes overall, not just on the individual items – our artist felt the lower plate didn't look quite right, so she 'erased' it with a brush (see Tip opposite) and reworked it.

Bring up the forms of the hydrangea leaves with cool greens for the shadows and warm greens for the highlights. Feather in some of the lighter yellows and light bluish violet on the plant pot and blend some light cold green on to the upright plate. Shape the bowl on the left with blended strokes of blues and yellows and the limes with shades of green.

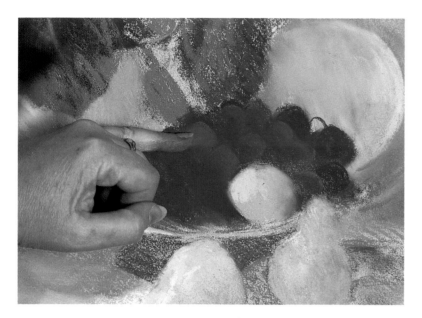

◄**11** Start on the purple grapes, first softening and blending the original marks with your fingertips. Then, with both shades of bluish violet, make curved strokes to bring out the individual grapes, softening the marks with your fingertip to create smooth, rounded shapes.

Tip

Brush off
If you make a mistake with pastel, the best way to remove it is not to blend it in with your fingers as you

might expect, but to brush it off lightly with a fairly soft brush. Keep a brush to hand just in case.

►**12** See how the grapes are emerging. Notice that those on the right, in shadow, are rendered more impressionistically than those in the light. Don't blend the colours too much – the slightly crumbly texture of the semi-blended colour captures the characteristic bloom of the purple grape skins.

Use very light cold green to bring out the light tops of the grapes and ultramarine deep to cut in between them.

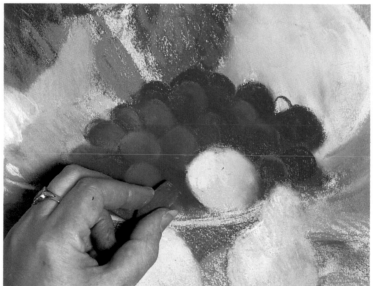

◄**13** Now work up the green grapes at the back in the same way as the purple ones, but with slightly less detail so they don't jump forward.

Develop the pears with ochre light, applying linear strokes over the blended colours to bring out their slightly angular forms. Then draw in the stalks with orange ochre. Work on the shadows around the picture and add the highlight on the left pear with light sunproof lemon yellow.

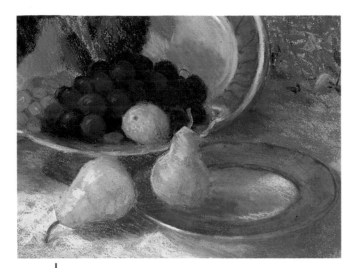

14 Continue to add tiny touches of colour around the picture to model the forms of the fruits and china and to capture the warm glow cast by the table lamp on the left. Notice how the artist has added pale but warm tones to the rims of the plate and dish to show the way the light catches them.

15 A good way to make the light areas look lighter is to darken the dark areas – creating a greater contrast. So build up the shadows with soft blues and grey blue, letting glints of the ground show through. Develop the plates, smoothly blending the colours and adding highlights. Complete the plant on the right with angular marks of your green pastels.

16 Refine the shadows on the table with mid bluish violet, softening it with your fingertip. Use the same colour plus grey blue for the shadows on the white plates. Lastly suggest the table front with vertical strokes of mid bluish violet. Keep the marks light and sketchy – don't create a hard line cutting across the picture.

 The finished picture has a relaxed mood, created by the dominance of blues and softened by the touches of yellow and green. The artist has picked up on – and emphasized – the golden light from the lamp to play up the yellows in the composition and bring out the blues by contrast.

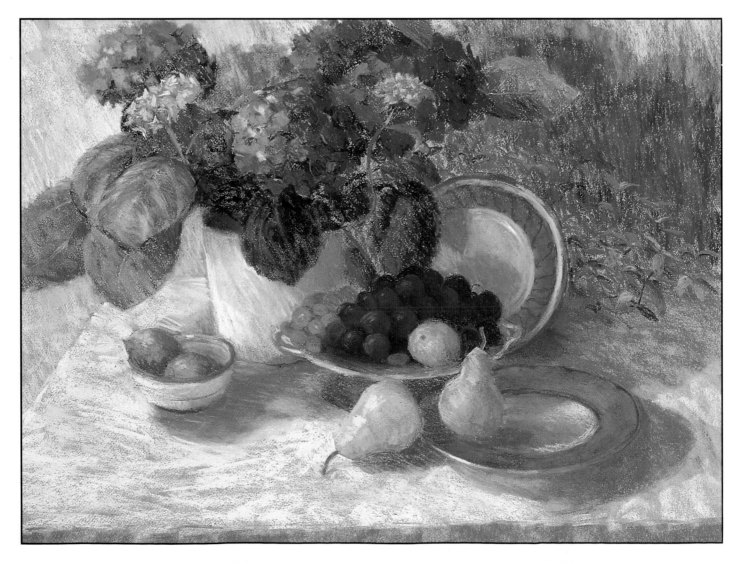

Overlaying colour in pastels

Overlaying thin, loose strokes of pigment allows you to build up tones and colour gradually without the risk of clogging the paper and making it unworkable.

Bold, thick pastel strokes can quickly build up on the paper, clog its tooth and prevent you from adding any more colours. You may be forced to stop before the picture is finished.

To avoid this, you need to pace yourself in the early stages. Work lightly and loosely, and use open strokes of scribbled colour, leaving plenty of paper showing between. This way, you can overlay several layers of pastel, with each new layer having a certain amount of fresh paper or thin colour to adhere to.

A loose scribble technique enables you to build up the tones and colours gradually but effectively without overworking the paper. You can also make use of the direction of the strokes to help describe the form and shape of the object you are drawing.

The grapes and apples in the picture on the last page of this project aren't lifeless one-dimensional objects, nor are the colours flat. Bright, rich colours and realistic shapes are rarely as simple as they seem. The artist, Humphrey Bangham, used several different reds for the apples (carmines, alizarin crimson and deep red) – but also pale burnt sienna, madder lake deep, medium burnt umber and pale Prussian blue. For the grapes he chose violets, reds and pale burnt sienna.

In other words, the artist looked carefully for all the reflected and local colours in the subject and captured – even exaggerated – these to create a vibrant, realistic image.

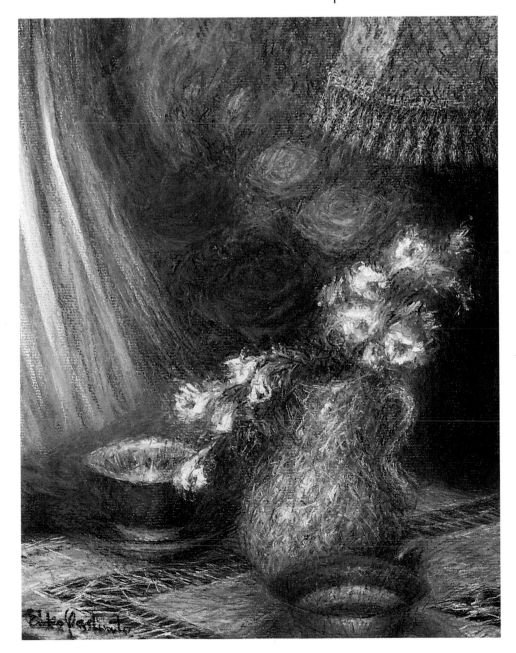

▶ There are many colour combinations in this rich, bright pastel composition. Notice the loose, curved lines of colour on the vase, giving it form and shape. To avoid making a flat, lifeless grey for the neutral background and cloth on the table, the artist overlaid four to six pastel colours in small flecks, dots and long, open strokes.

'Vase of flowers with teacups' by Eiko Yoshimoto, pastel on paper, 38 x 26cm (15 x 10¼in)

Practise overlaying colours

1 For this bunch of grapes, start with a pale red violet outline. Then fill in the first grape with strokes of madder lake deep, medium burnt sienna and violet. Sketch in the stalk with strokes of flesh tint and pale deep yellow.

2 Finish off this first grape with loose strokes of pale Prussian blue, pale ultramarine, dark burnt sienna, deep rose and medium burnt umber. Start further grapes in a selection of these colours. Use medium deep yellow and orange for reflections. Add orange to the stalk.

3 Work alizarin crimson, violet, both red violets and blue violet into the fruit. Use flesh tint, white and orange for the reflections. Add medium burnt sienna to the stalk.

4 Draw shadows with sepia. The finished image contains an amazing eighteen colours.

Bread, fruit and cheese

▶ **The set-up** A colourful arrangement of fruit, bread and cheese presents an inspiring challenge for any artist. Overlay your colours with care and sensitivity and you'll be able to capture all the tones and textures of this delicious still life.

◀ **1** Use pale red violet to draw in the outline of everything except the grapes, which you should do in charcoal. Sketch lightly so you don't affect the pastel colours to come. To avoid smudging, begin work in the top left-hand corner if you're right-handed (and vice versa if you are left-handed). Lightly scribble in the background with pale and medium Prussian blue, both ultramarines and white, then start the loaf with both gold ochres, medium burnt sienna and pale yellow ochre.

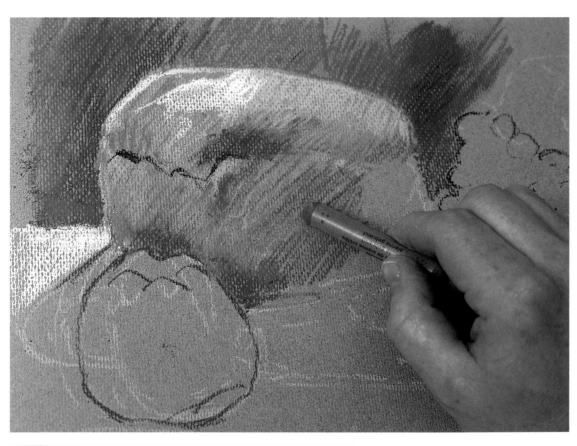

YOU WILL NEED

☐ A 28 x 40.5cm (11 x 16in) sheet of grey pastel paper

☐ One stick of charcoal

☐ Can of fixative spray

☐ 33 Rembrandt pastels or equivalents in other makes – pale yellow ochre, pale, medium and dark carmine, permanent deep red, alizarin crimson, madder lake deep, pale, medium and dark burnt sienna, medium and dark burnt umber, lemon, pale and medium red violet, violet, pale and medium Prussian blue, cobalt blue, flesh tint, orange, pale and medium deep yellow, blue violet, medium and dark gold ochre, deep rose, pale and medium ultramarine, white, green grey, pale grey and sepia

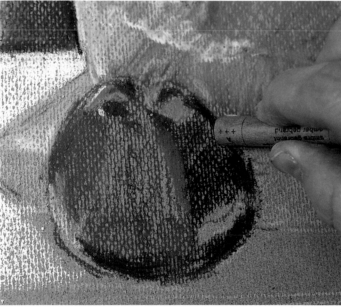

▲ **2** Continue to develop the overall tones and colours of the composition – again, make light, wide strokes to avoid clogging the paper too early.

The cool tones in the bread are pale ultramarine, pale red violet and blue violet. The top of the loaf is a combination of pale yellow ochre, white and flesh tint. Establish the shadows with dark burnt sienna, and build up the warm brownish tones with pale and medium burnt sienna.

▲ **3** Block in the breadboard with loose strokes using pale burnt sienna. Build up the left apple in all three carmines, deep red, deep rose, alizarin crimson and pale burnt sienna. The directions of the strokes describe the roundness of the fruit. Add the shadow on the right side of the apple with madder lake deep, pale Prussian blue and medium burnt umber.

▶ **4** Treat the bunch of grapes as one unit – don't render each one separately. Establish the bunch as a solid tonal mass of pale red violet, overlaid with loose strokes of medium red violet.

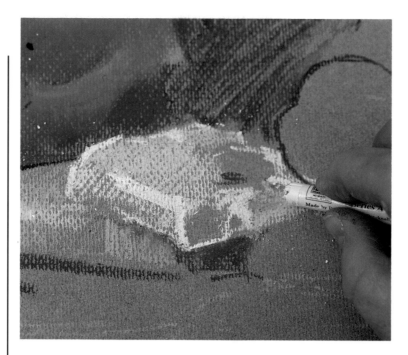

◄ **5** Before developing the grapes any further, begin forming the cheese with white, pale yellow ochre and lemon. For the cooler shadows, use cobalt blue and green grey.

Add pale deep yellow to describe the bright sections of the breadboard, then various strokes of medium and dark burnt umber and medium gold ochre to the shadow areas. Use white to suggest the curved edge.

► **6** Apply patches of pale yellow ochre and white rather thickly to the top of the bread to suggest the flour on top.

Add some warm mid-tones on a few of the grapes with small strokes or dots of pale burnt sienna. Don't overdo these, though; there are only a few. Use your white pastel to create highlights on some of the grapes.

Strengthen and extend the background with medium Prussian blue and medium ultramarine, and use the carmines to begin working on the second apple.

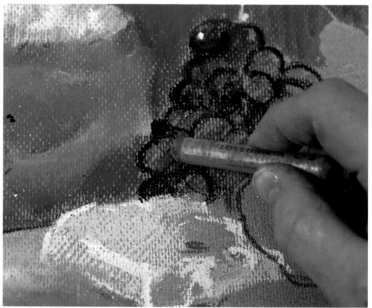

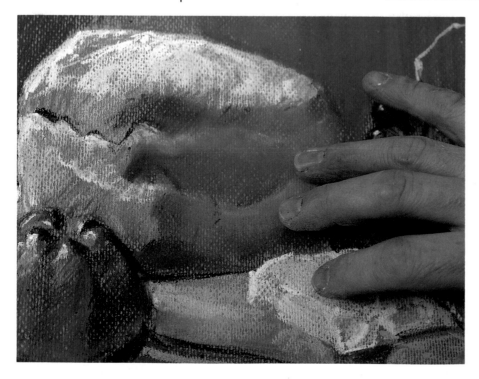

◄ **7** Here the artist lightly blends the yellows and white on the cheese with his finger to produce a smooth, creamy effect. But remember that too much blending makes the colours look lifeless and flat. It also clogs the tooth of the paper, making it difficult to add more colours later on.

Take a break from time to time to assess your progress and make any adjustments you think necessary to tones, shapes or colours. With any drawing, it's important to develop the work as a whole.

▶ **8** Still working from top left to bottom right, establish the second cheese in deep yellows, lemon and orange. Use medium burnt umber and green grey for the shadows. Look at the subject with half-closed eyes to find the tones.

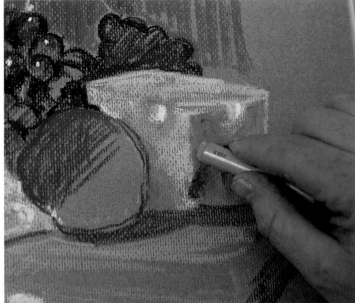

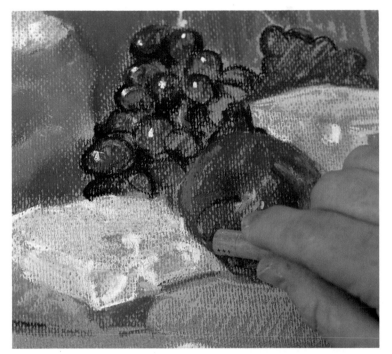

◀ **9** Finish off the second apple with various strokes of medium and dark carmine, deep red, deep rose, alizarin crimson and medium burnt sienna. Form the curved outline (on the left side of the apple) with deep rose. And don't forget to add the circular highlights in white.

▼ **10** Block in the tablecloth mostly with white. Use the broad side of your pastel to cover the area quickly.

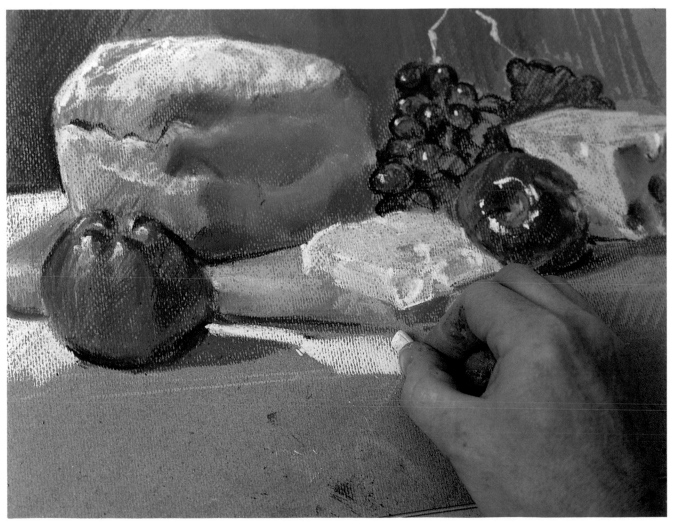

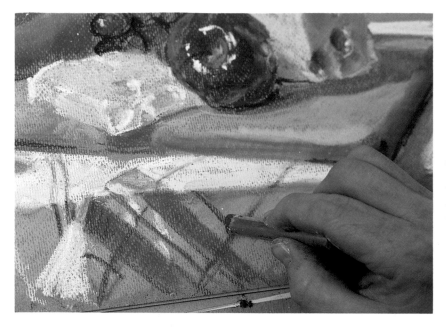

▼ **11** Your picture is almost finished. Continue adding details to the breadboard. A touch of finger blending on the board gives it a realistic, wood-like finish.

▲ **12** Use pale and medium ultramarine for the tablecloth stripes. Don't press too firmly; the paper should show through in some places. Knock back areas of the tablecloth with pale yellow ochre. The white of the cloth isn't flat; it has subtle patches of light and dark tones showing here and there.

▼ **13** Finally, complete the striped pattern on the cloth, and intensify the darker shadows under the board and fruit with blue violet and pale grey. Add more generous impasto-like white marks on the top of the bread (see step 6). Fix at once to prevent smudging.

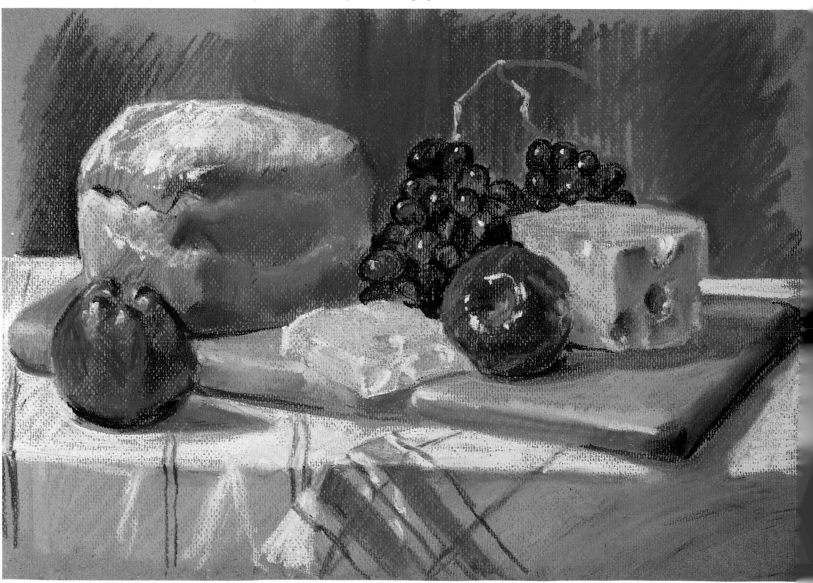

Hatching and scribbling

Simplicity is often the key to good picture-making. By using basic techniques such as hatching and scribbling, you can make a convincing pastel drawing with depth and character.

You may feel that once you master the simpler techniques of drawing and painting, the next step is to leave behind the basics and move on to more complex procedures. It's good to experiment with many approaches, but don't neglect traditional techniques. With pastels, you can create some wonderful results by hatching and scribbling.

In the demonstration drawing overleaf, the artist, Roy Ellsworth, blocked in the form of the boy, then built on this by hatching with more colours to modify the tones and create a three-dimensional image. He used bold scribbles to create an energetic background and to suggest the movement of the hair. Only with this foundation well under way did he finally begin to add the sharp details.

You can use hatched lines to give your pastel drawings a good sense of solidity. Hatching produces a crisp, linear effect that contrasts well with the soft, smudgy nature of pastels. It also creates a textured look.

Hatching is simply making regular strokes of similar length, quite close together and working in the same direction. Sharpen the tips of your pastels so you can make quite fine marks. You can add more colours to modify the tones and mix colours optically, but don't overdo it or you'll end with a muddy result.

Scribbling should come quite naturally. Scribble on colour loosely to produce an area of broken colour, as in the background. Scribble on more colours to create the exact hues and tones you need. Don't work tightly – keep your scribbles free and widely spaced.

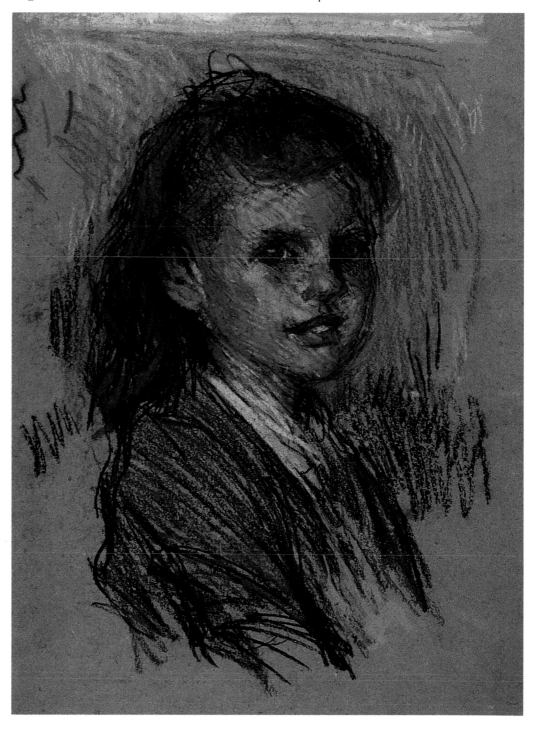

▶ Bold, loose hatching and scribbling give a lively energy to this child's portrait. The artist has made little, if any, attempt to blend and soften the robust pastel marks, yet this doesn't detract from the charm and delicacy of the little girl.
'Head of a Girl' by Sir George Clausen, pastel on paper, 35 x 24cm (13¾ x 9½in)

YOU WILL NEED

- [] *An A3 sheet of grey pastel paper*
- [] *Drawing board and pins*
- [] *Thirteen Faber-Castell Polychromos pastels: light orange, blue green, rose carmine, light magenta, cream, light flesh, medium flesh, Indian red, light ochre, burnt carmine, dark sepia, white and peacock blue (if you don't have this range of pastels, use the equivalent colours from your own range)*

Portrait of Jonathan

▶ **The set-up** Pastels are excellent for portraits, especially those of children. There's something about the smooth quality of this medium that complements the delicate texture of young skin. The bright hair and happy smile of this child make this photograph a good starting point for a pastel portrait.

◀ **1** Draw a square with the light orange pastel to establish the format of your drawing. Then use the side of the same pastel to block in the boy's form and place his facial features. Suggest the outline of the hair with a few loose, expressive scribbles.

Keep your marks light at this stage so you can make adjustments until you're happy with the general effect, before you commit yourself to firm outlines.

▶ **2** Use the side of your blue green pastel to put in the boy's sweatshirt. Hatch on top of this loosely with rose carmine. Then switch to the tip of your blue green stick to outline the boy's face and neck.

Scribble in the background using the side of the light magenta stick. Try to lay down the colour as solidly as possible. Then scumble over this with the cream stick. (To scumble with pastels, use a wide, rounded scribbling action.) These two colours are pale shades of yellow and violet, which are complementary colours. When placed together in this way, they each heighten the effect of the other.

3 Begin to hatch in the flesh tones on the face and neck with the light flesh stick. Do this quite gently and freely, so that your picture remains adjustable. Use blue green to sharpen the jaw line on the left. Pick out the dark tones on the nose, mouth, the side of the face, under the chin and in the hair. Hatch these in with your Indian red stick.

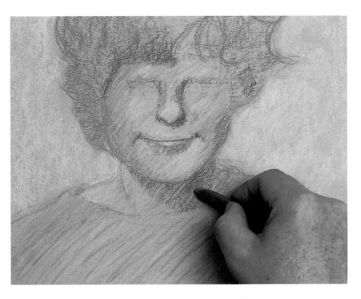

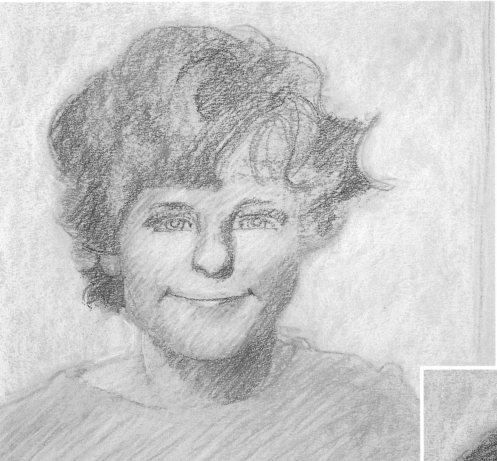

Tip

Drawing eyes
When drawing eyes, don't simply use black for the pupils and white for the whites. This gives the eyes a hard, unnatural appearance, like that of a doll. Tone down the whites of the eyes with a bluish grey or earth colour and put in the pupils with dark brown, for example.

4 Continue adding dark tones to the hair with Indian red. When you hatch in the hair close to the face on the left, keep in mind that you're allowing the shape of the ear lobe to emerge at the same time. Use the sharpened tip of the same stick to draw in the eyes and eyebrows. Once you've done this, continue building up the face with the light and medium flesh sticks for the light and mid tones. Blend the areas of tone together gently where they meet.

Even at this early stage, it's a good idea to establish the dark and light areas to give the picture a three-dimensional feel.

5 Intensify the mid tones in the hair by hatching over them with light orange. Then continue with the gradual build-up of the face, using the light and medium flesh sticks, and Indian red for the shadows. Notice how the artist develops the eyes, using small patches of different tones to depict the depth of the eye sockets.

The light shines from the left, so outline the jaw on the right with Indian red. Also use this to continue the modelling of the hair with small, circular motions, laying a dense tone for the darkest areas and a more open hatching for the slightly lighter areas.

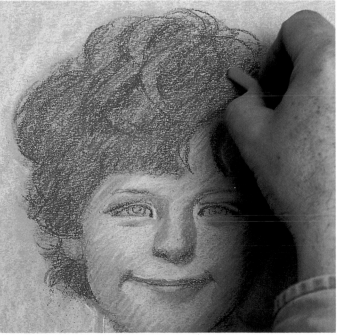

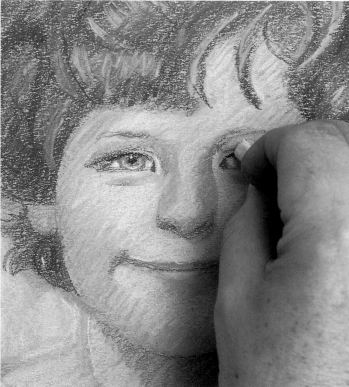

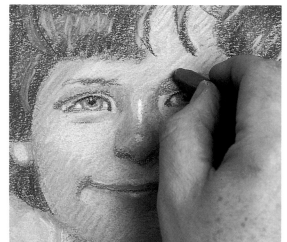

◀ **6** Give the hair more form, using light ochre for highlights and burnt carmine for the deep shadows.

Put in the pupils and the lines of the eyelids with dark sepia. The artist chose brown instead of black since black would stand out too much (see Tip on previous page). Put in the irises with light orange. Draw over them with blue green then blend with white. Dot in tiny white highlights on the pupils.

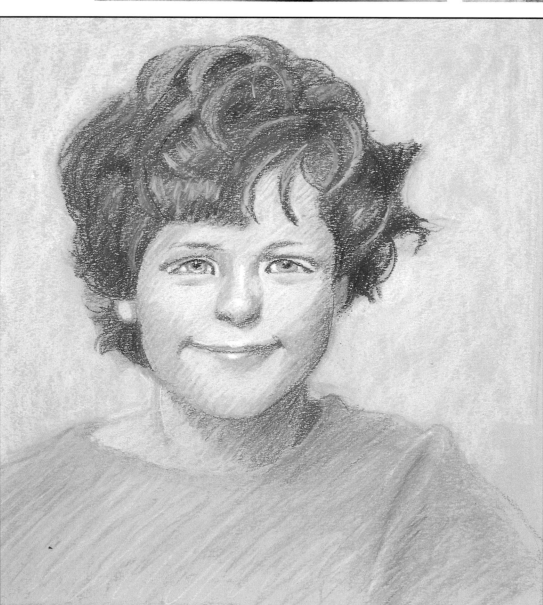

▲ **7** Stay with the white to add the highlights on the nose and mouth. (Be careful not to smudge your drawing by resting your arm on it accidentally.)

Use Indian red to re-establish any dark details that have become subdued, such as the eyebrows and the edges of the eyelids. Use it also to re-emphasize the darker shadows in the hair. The greater the range of tones in the hair, the more life it will seem to have.

◀ **8** Add the finishing touches. Suggest the form of the boy's sweatshirt, and his figure beneath it – use white for highlights, and peacock blue for the shadowy folds. The artist chose not to use fixative on the portrait since he felt it would dull the bright colours. If you do the same, protect the drawing first with tissue paper, then frame it under glass as soon as possible.

The finished portrait shows how simple techniques such as hatching and scribbling can create some wonderful results. The artist has captured the volume and life of the hair, and the fine quality of the boy's skin.

Dynamic portraits

For exciting portraits which will seize and hold the viewers' attention you must be bold and allow your own emotions – and your model's – to play their part in the creative process.

Set aside all your fears and inhibitions, and put body and soul into the drawing process, letting your emotions flow and trying to put down on paper what you feel, what you perceive your model to be feeling and what you are absorbing of the atmosphere. You may not make pictures as striking as these, but you'll be unlocking the door to your creativity and you'll be nearer to becoming a true artist.

Aim to make every mark count. Each stroke or dot of the pastel should convey something of how your model looks, or express your response to the model and the pose – the artist here, Ken Paine, calls these 'emotional lines'. By combining both types of marks you should be able to create a picture which is both a good likeness – vital for good portraiture – and a lively and interesting drawing in its own right.

◀ **The set-up** Consider the model's pose carefully. Since your aim is to put emotion into this picture, you need a pose which inspires you. But as always, don't lose touch with your model's comfort. If the pose is too uncomfortable for the model to hold for any length of time, you won't be doing yourself any favours either.

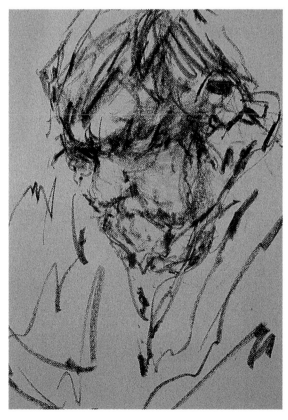

▶ **1** Tick in the main features on a large sheet of mid grey pastel paper with a Vandyke brown pastel. The artist works from the hair down. You may find it easier to start by drawing an inverted triangle of the mask of the face which marks the eyes and mouth positions. Notice how the nose is to the left of the triangle and not in the centre. Next, draw another triangle for the cheeks and chin and see how this second triangle is parallel to the first.

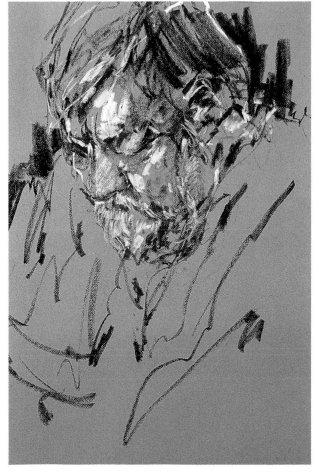

◀ **2** Use the cream pastel to put in some judicious highlights. You're not using it to show colour – in the hair, for example – but to show where the light falls.

See how the artist has managed to show so much using just two pastels. He doesn't erase anything because each mark is important – each is an expression of his response to the model. Compare the finished picture with the set-up. The artist has created an image of a powerful man now bowed down by life's experiences. But his other pictures of the same model (overleaf) tell quite a different story.

The intuitive approach

Pastel is a very direct medium – you can just pick up a stick of colour and use it straight away, without having to squeeze a tube, choose a brush or mix the exact tone you want on a palette. It is, in fact, the perfect medium for working intuitively, straight from the heart.

So if you are drawing a portrait in pastel, take advantage of this positive feature of the medium and allow your emotions to play their part. Put something of yourself into the picture, and you should not only achieve better results but the experience will be more satisfying.

Use each pastel to its full potential, taking advantage of the point to make generous, expressive calligraphic lines and using the side for softer, more serene blocks of colour. As our artist says, 'a line is like a musical note – you can either caress it or hit it.'

The set-up For this portrait the model is in more or less the same position as before, but to give him a stronger, more powerful image, the artist asked him to look up slightly.

▶**1** Use a black pastel to tick in the shape of the head and features. Then dip your brush in water and draw over your lines, extending the drawing using the brush alone – some black pigment will cling to the brush, creating a soft grey mark. Work vigorously, using the brush to shape the forehead and nose. Add more tones with the Vandyke brown pastel.

At this stage you should already have put down the basic shapes and rhythms of the pose, giving you a recognizable likeness. If not, either re-examine and adjust your drawing or throw it away and start again – everything builds on this first stage, so if it isn't right then the picture won't work.

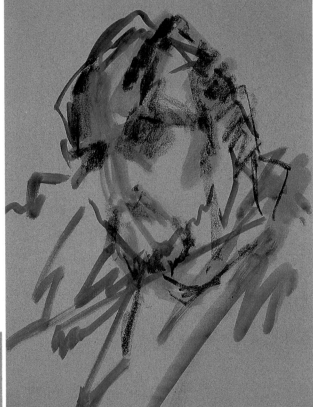

Tip

Water works

Diluting pastel with water is a traditional technique, but make sure your brush isn't too wet if you want to avoid runs. (You may, of course, wish for a very wet effect.) An alternative is to dip the end of the pastel in water and draw with it, but the wet colour is used quickly.

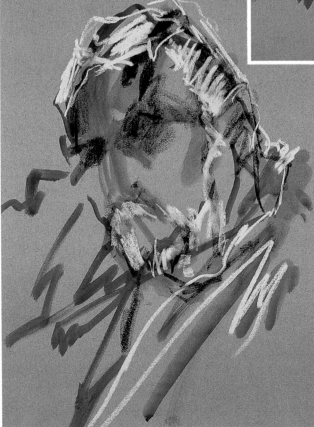

◀**2** Now introduce a few highlights with a pale colour such as the very pale cobalt blue chosen by the artist. (It is worth noting that a pale tint of a colour often makes more interesting highlights than pure white.) Work the pastel enthusiastically and energetically, creating gestural marks which are a direct response to what you see and feel.

▶ **3** Use your wet brush and black pastel to add a dark tone behind the face which pushes this area back and brings the face into relief.

Paint the nostrils with the brush and make any other adjustments before introducing a skin tone. The artist chose light cadmium yellow for this, using it only for areas of mid tone. Notice how he uses the pastel to its full potential, carving outlines with the sharp tip and creating softer tones with the side.

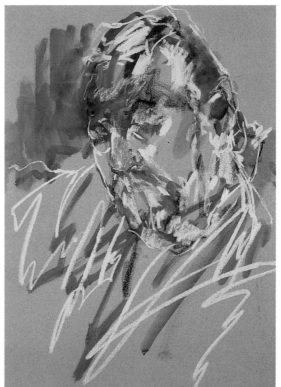

▽ **4** For the warm areas of the face, such as the cheeks, parts of the forehead and neck, apply deep cadmium yellow. Make sure your marks follow the direction of the planes of the face – notice how the artist shades the cheeks with diagonal strokes, while using near-vertical strokes on the forehead. Now use Vandyke brown for areas of deep shade – on the eyes, nostrils and beard, for instance.

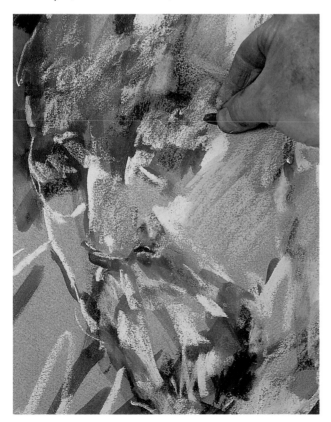

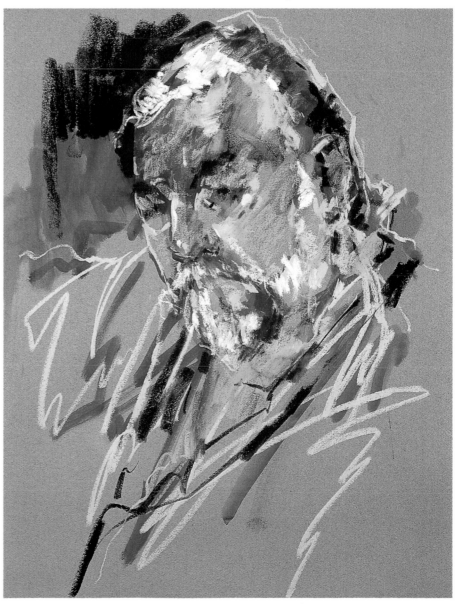

▶ **5** Put in the final details, adding cream pastel to the hair to warm and lighten it. Try the same colour for the brightest highlights on the face and beard to add continuity.

The artist has concentrated on the face, contrasting a dense application of colour here with open, dramatic and energetic strokes on the body which give the finished drawing a strong, powerful feel. This reflects on the model, making him appear strong and powerful too.

The Roman lion-killer

The artist always looks for something in the face of his model that inspires him and can provide a clue to the mood of the finished picture. Associations often help to show the way, but you have to look for them and take the time to explore possibilities. However, it's well worth the effort because it should enable you to create a much more emotive portrait.

At first the model reminded the artist of a magician, but when he moved his head slightly into this thoughtful pose, he looked 'like a Roman who has just killed a lion'. The artist captures something of this in his picture below.

The colours you use will inevitably help to convey mood, so use them intuitively, rather than simply repeating what you see. The artist's colours are not designed to be naturalistic – he works with colour instinctively, often using old favourites such as black – 'the prince of colours' – warm browns and brilliant yellows.

YOU WILL NEED

- [] *A large sheet of dark grey pastel paper*
- [] *An assortment of soft pastels including: cream, very pale cobalt blue, deep cadmium yellow, pale vermilion, scarlet lake (or mid vermilion), Vandyke brown, mid grey and black*

◀**1** Start by plotting the hair, eyes, nose, chin and shirt of the model with the Vandyke brown pastel. These marks should already have captured a likeness, but it's also important to get down something of your emotional response to the model and his or her pose. Do this by using gestural marks – vigorous marks if you feel there is tension, anger or aggression; soft marks for a calm, quiet or contemplative mood.

▶**2** Work on the nose, forehead and cheeks with deep cadmium yellow, sculpting the nose by pressing hard on the bridge and working softly on the side. Use this colour on the neck, working the pastel with a light touch here to prevent the neck leaping forward too much. Dot in a little yellow beside the mouth where the skin shows between beard and moustache.

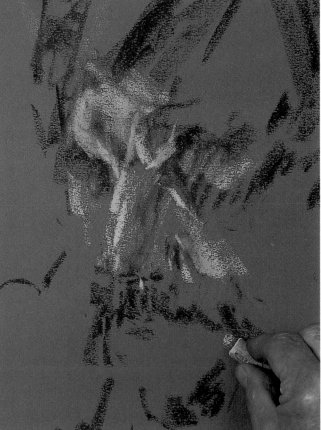

▶ 3 Try a pale colour such as very pale cobalt blue for the moustache and beard, allowing some of the brown to show through. Use the Vandyke brown pastel to touch up the eyes and to shade the side of the nose, cheek and hair – and any other areas which need work.

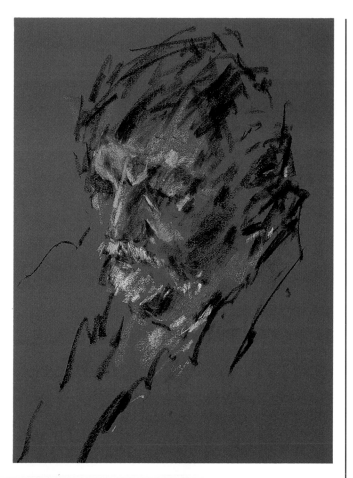

▼ 4 Work up the hair with more brown and a little yellow. Darken the background behind the face to throw it into relief, then put some very pale cobalt blue into the hair and sideburns. Use this colour to reshape the hair, if necessary.

The artist points out that every mark he makes is balanced by another mark, so the tip of the beard is balanced by marks at the back of the head, for example. Even if the balance isn't there in reality, he makes these marks to create harmony. He positioned the ear with yellow – this is vital because it balances the tip of the nose. Likewise he offsets a black stroke at the front of the head with one at the back of the neck and another at the bottom of the beard. (Notice that these marks also help contain the image.)

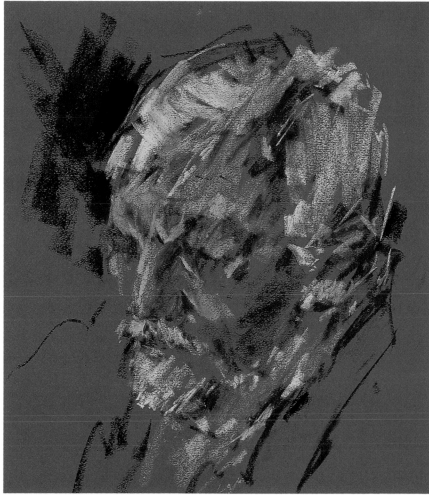

▼ 5 Add more black – on the eyebrows, eyes, nostrils, under the beard and behind the head. Work up the hair with very pale cobalt blue and Vandyke brown, and also with the Vandyke brown, start to indicate the shirt – this is an opportunity to use emotional lines, rather than simply copying the creases in the shirt.

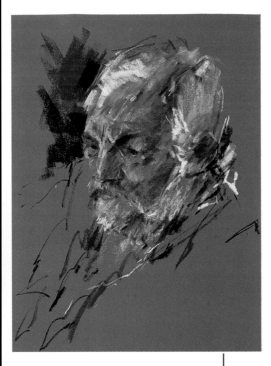

◄6 Continue building up the portrait, adding a hot red orange such as mid vermilion or scarlet lake where you want a warmer colour. Balance each mark with another – red on the ear and near cheek offset with red on the neck, forehead and far cheek. Add mid grey to the hair, including the beard, and add highlights with cream.

►7 Carry on developing the face, using pale vermilion for the warm highlights. Notice in this close-up how boldly the artist has stroked in the colour.

►8 To complete the picture, develop the background around the head and add a few more 'emotional lines' to the shirt. Tidy up the hair and make any other final adjustments, adding further colours if you feel they are appropriate for the mood of the picture. The artist uses colour instinctively, so use your own colours in this way too, rather than simply copying his choice.

This is a picture which succcessfully conveys the strength and power of the sitter – quite different from the mood of the other two pictures. You could imagine that if the same artist painted another three pictures of this sitter, they would all have different moods too.

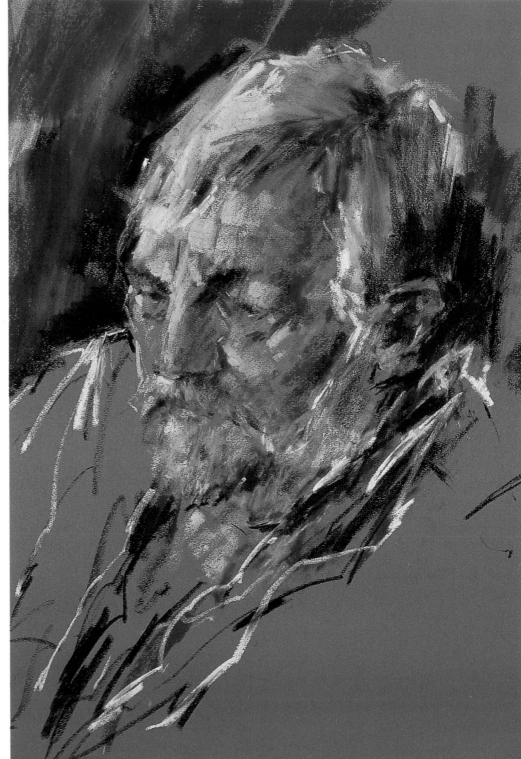

Painting with pastel pencils

Pastel pencil effects – balanced between the painterly qualities of pastel sticks and the linear qualities of coloured pencils – are excellent for rendering sensitive portraits.

Pastel pencils have the intensity of colour associated with soft pastels but they are harder, so they can be sharpened to a point for linear details. They are ideal both for direct, bold sketches and for dense, detailed drawings which have subtle nuances of tone.

For this portrait, the artist, John Raynes, used the pencils primarily for line, adding only some loosely scribbled shading and a little hatching. The highly pigmented coloured lines, with a little smudged or scribbled tone, can speak for whole blocks of local colour, such as the subject's bright red shirt. The white of the paper, therefore, becomes a dominant feature of the finished drawing – a space out of which the head emerges with the greatest economy.

Only 12 Conté pastel pencils are used in this drawing. If you don't have the Conté range, you could use one of the other equivalent ranges on the market: Rexel produces 'Rexel Derwent Pastel Pencils' in a range of 90 colours, and Schwan-Stabilo has 80 colours in the 'Stabilo Carb Othello' range.

◀ **The set-up** The sitter wears a scarlet shirt and a striking black hat for an effective colour contrast. The hat shadows his forehead, adding extra substance and interest to the face.

▼**1** Start by indicating the location of the eyes. Use yellow ochre to lay in the main outlines and lightly scribble tones around the eyes, with madder for the warm tones on the cheeks. Sketch in the irises with light blue. At this stage, keep all your marks very light to allow for corrections and changes of emphasis.

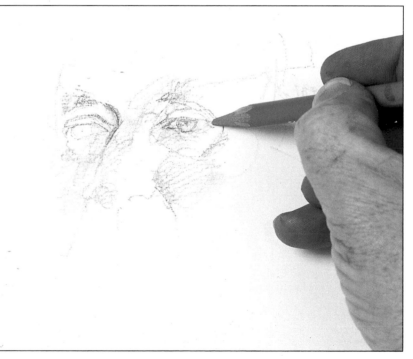

◀**2** Get the proportions between eyes and mouth right, and you should achieve a likeness. Check these measurements all the time and remember – if the model moves his head, the apparent relationship between the eye and mouth will change.

Tick in the nose and mouth, again working lightly. Use the warm yellow ochre for most of this. Locate the dark tones within the nostrils and between the lips and darken them slightly. Shade under the fullness of the lower lip – light coming from above casts this area into shadow. Use a light line to describe the chin.

YOU WILL NEED

- ☐ A 38 x 56cm (15 x 22in) coarse-grained mounting board sheet

- ☐ Twelve Conté pastel pencils: yellow ochre 17, Naples yellow 47, raw sienna 18, garnet red 39, madder 38, flesh 48, light blue 29, red brown 7, raw umber 54, grey sepia 42, light grey 20 and black 9

- ☐ One white soft pastel

▶ **3** Now indicate the hat with black. Locate the ears – they help you to establish the volume and roundness of the skull. Use a pencil to measure the relative distances: notice that in this pose the mask of the face (the area of the eyes, nose, mouth and chin) occupies quite a large space, when compared with the cheek and the side of the head.

The ear aligns with the top of the eye socket and the end of the nose. Use madder for the ear. Hatch in flesh colour and Naples yellow on the forehead and for the lighter tones on the side of the cheeks.

▼ **4** Continue developing the darker tones under the chin and around the neck. Use a combination of ochre, madder, red brown and raw umber, blending the colours into an optical mix. Add white pastel where the nose catches the light.

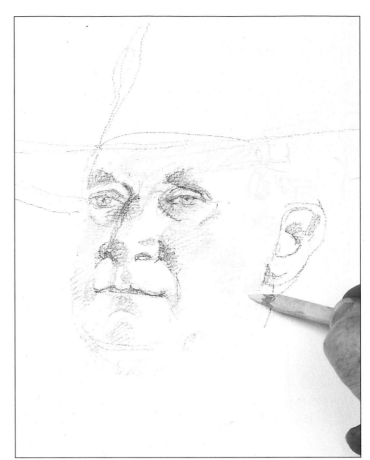

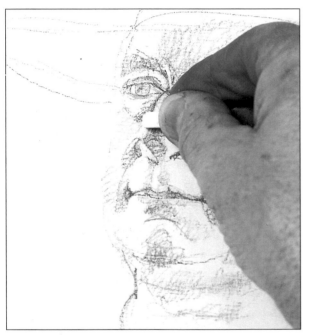

▶ **5** Work on the hat in grey sepia and black. Use line for the broad shape, but shade in the underside of the brim. Draw in the shirt with garnet red and red brown, and indicate the subject's hair with light grey.

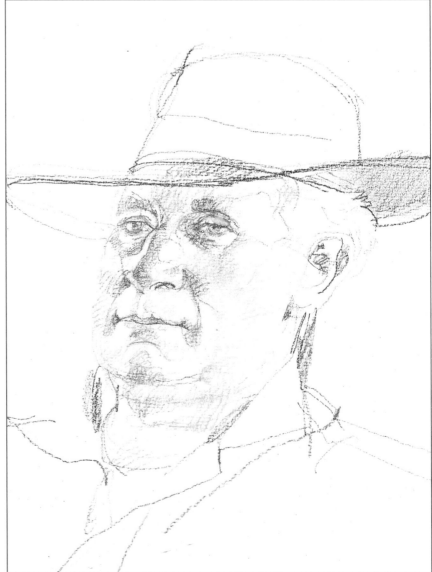

▶**6** Using the black pencil, add more dark tones to the underside of the hat brim on the left. Smudge yellow ochre over the neck to create a soft, graduated tone. Build up the ears, cheeks and shirt.

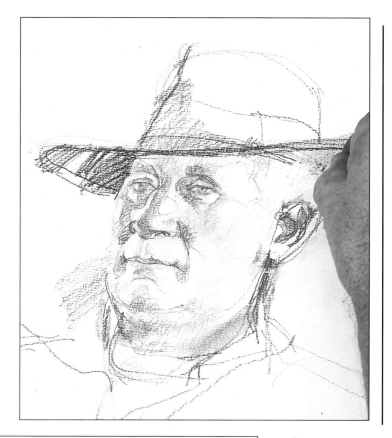

▼**7** At this stage the face is well established. Add more detail to the hat, drawing in the crown with black and adding darker tones in grey sepia. Using raw sienna, yellow ochre and garnet red, add dark tones to the turned-up collar. Indicate the broad outline of the shirt in raw sienna.

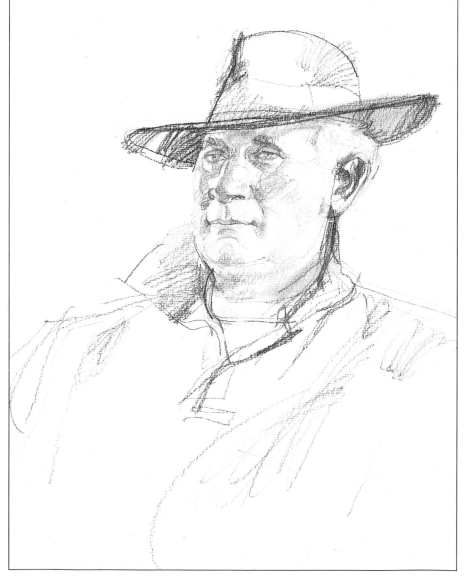

▼**8** Add emphasis to the shirt with fluid lines of the garnet red pencil. Note that a simple line of these highly pigmented pastel pencils can serve to indicate a whole block of local colour.

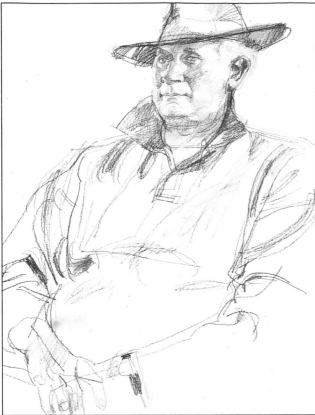

9 Outline the model's clasped hands with garnet red, and scribble in a little yellow ochre and raw umber. Shade in the watch strap with black: apart from adding an extra element of design to the composition, this indicates the form of the wrist.

10 In the finished drawing, the upper body simply supplies an elegant context for the more fully realized face. However, in the final analysis it is up to you to decide how far to take each element of the composition.

Tip

Go easy

Conté pastel pencil is almost impossible to erase once deep impressions have been made on the support. It is therefore advisable to outline the forms very faintly before you make more decisive marks.

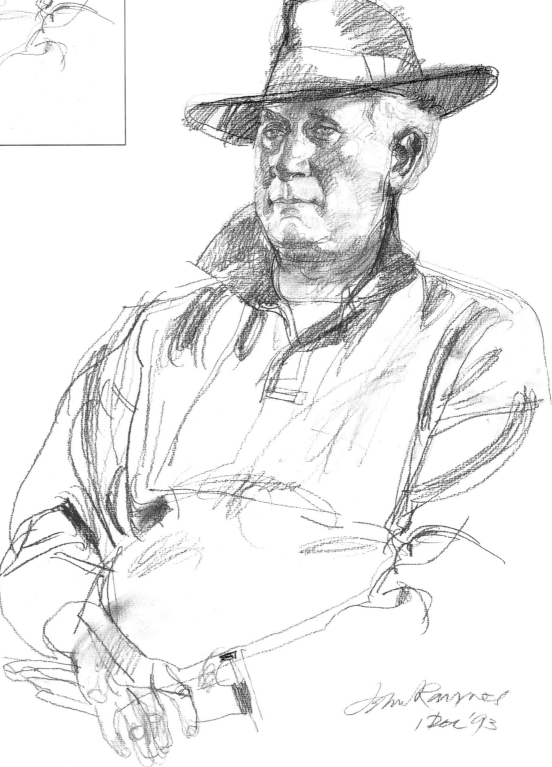

Restraint and broken colour

A handful of pastel sticks and a sheet of warm-toned paper are all you require to create this delightful sunny interior.

With their powdery yet vibrant colours and spontaneity of application, pastels are often chosen for intimate still-life drawings of fruit, vases of flowers, china and so on. But they are equally good on a larger scale – rendering the textures, subtle shadows and soft lighting of room interiors, for example, while still retaining the sense of intimacy typical of a classic still life.

Here the artist, Lynette Hemmant, chose a fairly limited range of pastels – just 17 colours (pastel artists may use 30, 40 or more different shades). This has made for a gentle, serene, sunny picture where no one colour is allowed to jar or sound a strident note.

The way she works with her pastels is also unusual. Her strokes are fine, with lots of crisp detail, and she makes maximum use of the warm tone of the paper, producing shimmering broken-colour effects with very little blending or build-up. The pure colours, used with great restraint, stand on their own – a refreshing change from the big, bold swathes of colour usually associated with pastels.

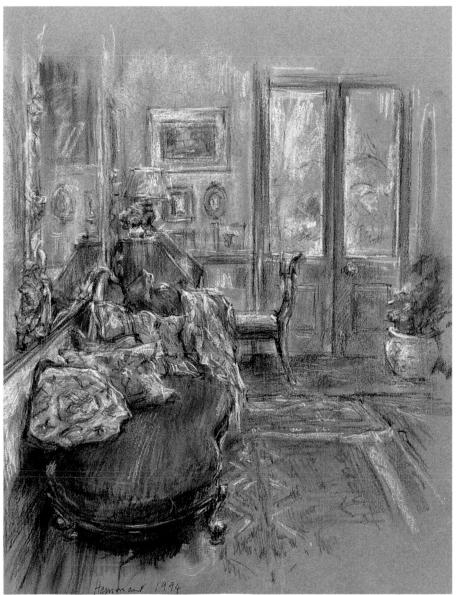

▲ ▶ When an artist works from life, it's interesting for the viewer to compare the final picture with what he or she was actually looking at. This way, you can see what was important to the artist – the viewpoint and even the individual way of interpreting colour and tone.

The photograph above shows, as nearly as possible, the view that the artist drew. This is the artist's own sitting room, a wonderful assembly of textures and colours – all reflected in her rich pastel drawing (right) with its subtle rendering of fabrics, rugs, gilding, glass and wood.

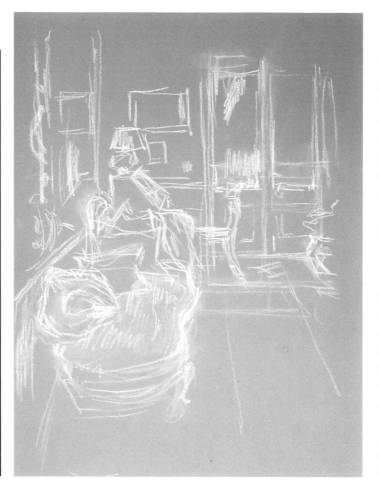

◀ **1** Use the white pastel pencil to map out the main elements in the room (see the set-up photo on the previous page). Even at this early stage, bear in mind the range of tones you want. The colour of the paper acts as the mid tone, so look for the lights and darks on either side of it. Scribble or hatch in some of the lightest tones with the white pencil. (This white underdrawing is important since it is never wholly eliminated – it gives a shimmering quality to the whole work.)

▼ **2** Roughly block in some of the main purples, browns and blues in the picture – the chaise, the French windows, the rugs. Gently blend the colours with your fingertip to create more subtle tones.

Use the edge of the dark madder brown stick to redefine the cushions, chaise, rugs and chair. Outline the lampshade, the pictures on the walls and the mirror edges. Keep all your strokes very light at this stage.

◀ **3** Work up the chaise in broad strokes of violet and purple, smudging with your fingertip to blend the colours. Note that the colour of the paper itself stands for highlights on the edge of the chaise. Apply cobalt blue, lightly blended, under the front of the chaise for the dark shadow it casts. Also put in a few lines of vermilion for the rugs – the different direction of the strokes here already suggests the weave of the rugs.

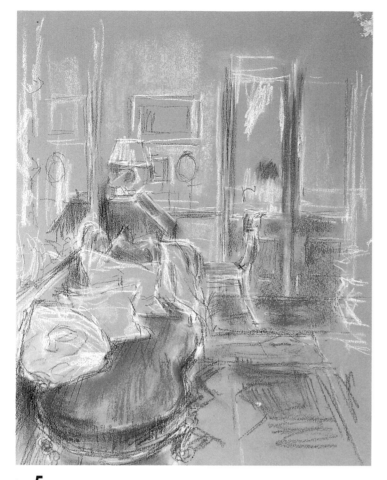

4 Continue building up individual elements in different colours, working all over the picture. Use burnt sienna for the French windows and the shadow in front, deep lemon yellow for the walls, vermilion for the rugs and touches of pale Prussian blue on the cushions. Use violet on the chair, and dark madder brown and a little burnt sienna on the desk (use the same for the reflection of the desk in the mirror).

Now spray the picture with fixative to prevent the colours smudging or rubbing off. Then stand back and assess your progress so far – this will help you see which elements need attention.

5 Concentrate again on the tonal elements. Hatch dark madder brown, violet and purple over the shadow under the front of the chaise (this is the darkest tone in the picture). Keep the pastel strokes loose and free. For more intense areas of colour, blend with your finger. Touches of every colour appear almost everywhere – this helps to make all the tones lively, particularly in the dark areas, and gives the picture coherence and harmony.

7 Now put in more small touches of colour everywhere. Redefine the shawl and cushions with dark madder brown to make them stand out, then fill in details of the cushion fabric with dots of your blues, reds, yellows, greens and browns. Touch in dark blue, purple, violet and white for the pot of flowers on the right. Put in some slanting blue and red lines on the rugs, but not too much detail – you don't want to draw all the attention down to the floor. Note the blurry reflections of the desk and pictures in the mirror and in the French windows.

6 Apply white pastel to the French windows in the background – this helps to suggest the glass. Blend the white over the purple reflection in the window – but don't obscure it completely. Again, make sure you never cover the paper completely – this picture relies for its effect on the subtleties of broken colour.

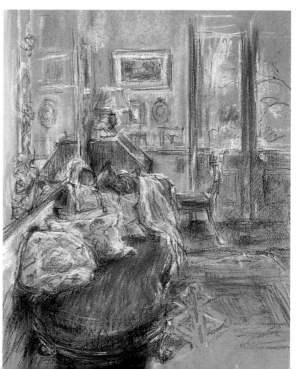

▼8 Returning to the white pastel pencil, apply highlights in short strokes on the cushions, the shawl, the edges of the desk and on the gilded, embossed sections of the mirror on the left. This also serves to tidy up and sharpen details.

▲9 Do the same with the black pastel pencil as the white – dot and dash around the cushions, refining their outlines and marking in their patterns more precisely. Continue with the same pencil around the edges of the mirror, the desk chair, the French windows and the area where the floor meets the door. Both the black and the white give crispness and strength to the whole drawing.

▶10 Finally, sharpen some of the detail on the reflections in the mirror. Darken the area near the top in black pencil, then dash in a few slanting streaks of white where the light catches the glass. Check your picture again for tones – squint at the scene to help you see them better. Put in any last tiny touches of colour where necessary, then spray with fixative so that nothing can smudge.

The artist has resisted the temptation to work things up too much. Although her technique – placing small strokes of colour, with lots of little touches here and there – could be quite time-consuming, the end result is a delicate and very refined finished pastel.

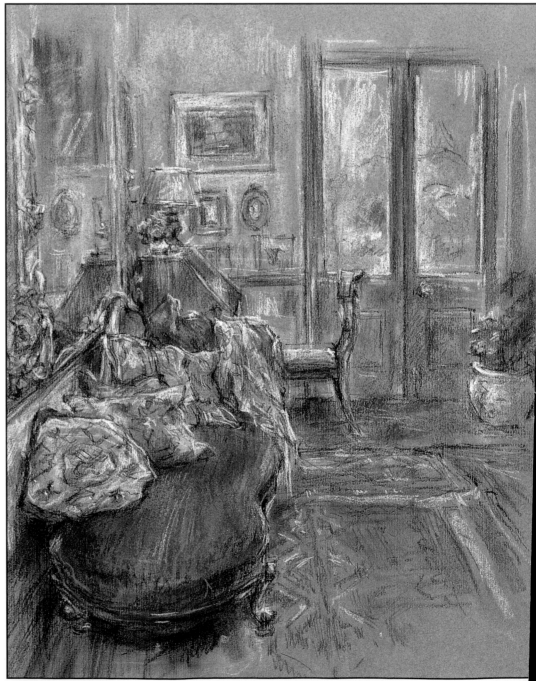

Bright colour effects

Combine a boldly coloured support with vibrant pastel sticks for a picture which will capture all the brilliance of a summer afternoon on the beach.

Pastel artists often have a wide range of colours at their fingertips, but the artist here, Godfrey Tonks, limited his palette to sixteen hues, relying on their saturated colours and his varied application of them to produce the effects he wanted. He used solid blocks of colour in some areas, contrasting these with areas of layered, hatched and scribbled colour, sometimes blended, sometimes left as broken colour.

Don't forget that the colour of your support effectively supplies an additional colour to your palette. The artist's choice – a vibrant terracotta shade – brought warmth and intensity to the picture. Being the complementary of blue, it enhanced the colours of the sea and sky by providing a contrast. Notice that the support shows through in the final image to give a liveliness and satisfying colour unity.

◄**1** Make a charcoal outline drawing of the scene, dividing the composition into its main components and carefully positioning each object or figure.

Note that the sunbathing figure in the foreground on the left has been brutally cropped. This helps to lead us into the composition towards the central area of the beach scene, and it gives the image a rather casual air, as if the artist had just glanced over from his position on the beach.

►**2** Cover the sky area with a loose layer of light blue. Go over this gently with cobalt blue – the light blue will show through so the two shades blend in the viewer's eye.

Use your fingertips to smudge the colours in some places, concentrating particularly on the area close to the horizon – the blended marks here help to suggest the sky receding far into the distance.

◄3 Use light green, white, light brown, ultramarine and mauve to scribble in the groups of houses and the foliage on the area of land in the background. Make the skyline a mixture of dark and cobalt blue. Working forwards, fill in the two jetties with black and dark blue, outlining their tops with white. Use white, light blue and cobalt to colour in the lighthouse behind the jetty on the left.

Now begin to work on the sea. Draw a line of ultramarine where it meets the strip of land in the background.

YOU WILL NEED

☐ *A4 sheet of terracotta-coloured pastel paper*

☐ *Thin sticks of charcoal*

☐ *Sixteen pastels: white, yellow, yellow ochre, pink, vermilion, mauve, violet, light blue, cobalt blue, ultramarine, dark blue, light green, light sienna, light brown, light grey and black*

▼ Keep your soft pastels in separate colour groups or they'll rub off on each other and end up looking like murky neutrals. These little nail and screw boxes provide an ingenious solution.

►4 Work light blue over the whole sea area, skirting around the outlines of the boats. Overlay strokes of cobalt blue here and there. Now add patches of ultramarine to indicate depth and the reflections of some of the boats in the harbour.

▲5 Continue to work on the sea, adding small patches of yellow ochre and light sienna. Use a considerable amount of white to indicate watery reflections – especially as the sea recedes towards the land in the background. Put some detail on the boats using black, white and ultramarine.

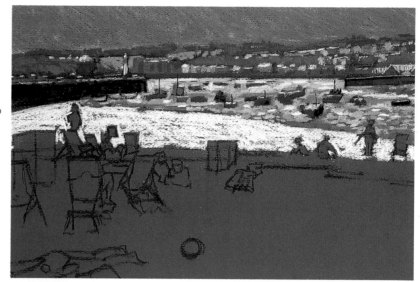

▶ 6 Draw in the beach by the sea's edge where the sunlight bounces off the wet sand – a great strip of light sienna. Add spots of vermilion to the boats and to the strip of land in the background.

Notice that the artist is basically working down the support from top to bottom. This avoids the danger of accidentally smudging previously coloured areas with the side of the working hand.

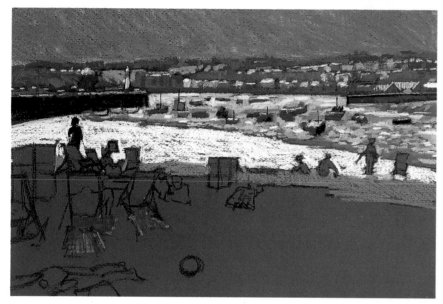

◀ 7 Concentrate now on the foreground beach area. Start by working in a strip of mauve below the light sienna area. Indicate the shadows of the beach chairs with ultramarine and mauve. Use black to indicate the shadowed figure on the far left.

▶ 8 Work on the brightly coloured wind-breaks using bars of vermilion and light sienna mixed with white and yellow ochre. Apply strokes of light sienna and light blue over the mauve strip of sand, and lightly smudge them in. Add the same colours to the wind-break on the right for continuity.

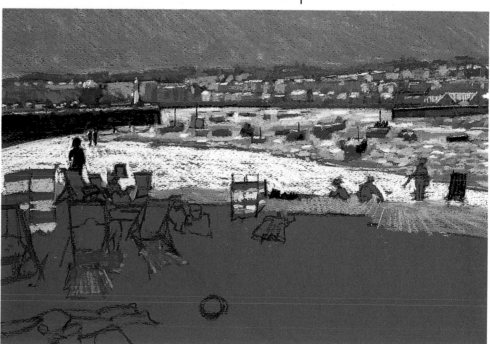

▶ **9** Begin to colour in the beach chairs using strips of vermilion, ultramarine and white. Bear in mind that whenever a person is sitting in a chair, they will block out the light passing through the fabric, making the colours darker than elsewhere.

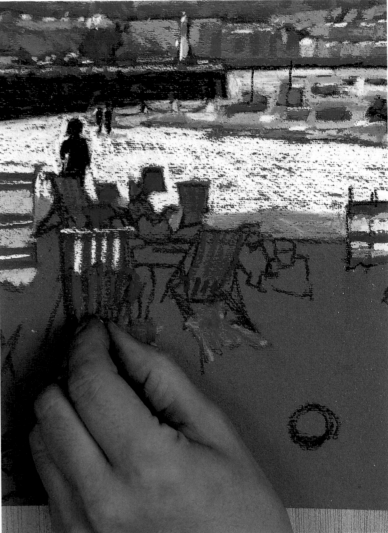

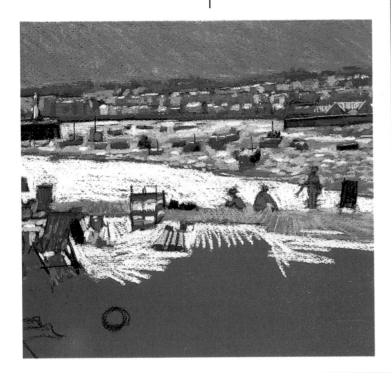

◀ **10** Work freely over the foreground, using light sienna for most of the sand on the right of the composition with a little yellow ochre for the darker sand between the beach chairs. Touch in any remaining beach chairs with vermilion or dark blue and black. Add light blue to the shadows of the beach chairs in the foreground.

▶ **11** Elaborate some of the figures now, varying the colours as you go. Give one figure an ultramarine shirt and light sienna trousers, another a white and green shirt and so on.

There are some rolled-up beach mats in the middle of the beach next to the newly coloured figures: indicate these with light sienna and vermilion.

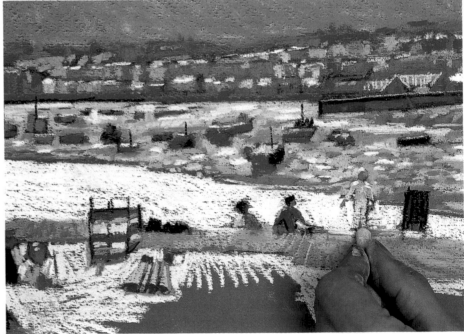

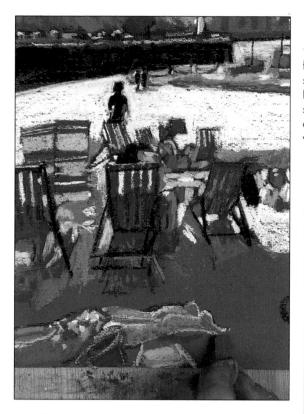

◄**12** Work now on the sunbathing figure in the foreground on the left. Touch in the colours of her swimsuit with green, ultramarine and cobalt blue. Indicate her legs and back with pink, light grey, light sienna and yellow ochre, with some light blue for the coolest shadows. Draw the bucket next to her using vermilion, and the segment of towel using green.

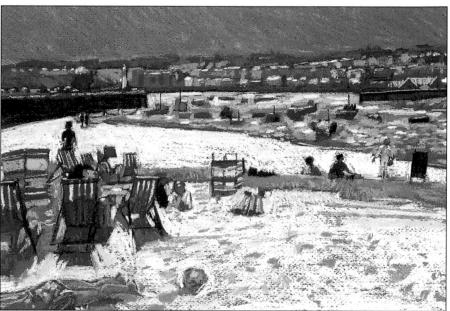

►**13** Range freely over the foreground section of the beach, filling in gaps with light sienna, yellow and patches of mauve and light grey. Colour the beach ball in green, cobalt and ultramarine, then indicate the hair of the lady in the beach chair on the left with black.

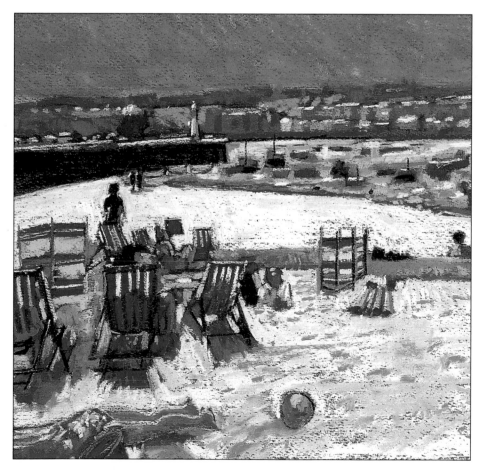

◄**14** Go back to the sky and intensify it with smudges of violet. Make the foreground section of the beach even patchier with yellow ochre and yellow.

At this stage every area of the picture should be blocked in. If not, fill in any remaining blank areas with appropriate colours. Remember, though, to allow flecks of the support to show through – these give the finished image a shimmering quality which perfectly captures the sparkling sunlight on the beach.

◀**15** Assess the colour contrasts in your composition – are they strong and bright enough to indicate something of the intense sunlight? If not, intensify some of the brighter colours, such as the yellow and red stripes on the beach chairs and wind-breaks.

▼**16** The drawing is now almost complete. Add more texture to the foreground beach area with streaks of yellow and spots of light grey – the extra detail here helps to bring this area forward. Lastly, brighten the sea with more dabs of light blue and white, blending them a little here and there with a

fingertip. Remember that the background areas should be fairly indistinct to ensure they recede.

Notice how the finished image is alive with colour and sparkle. The artist has boldly juxtaposed hot and cold colours, lights and darks, neutral and fully saturated hues for a brilliant, eye-catching image.

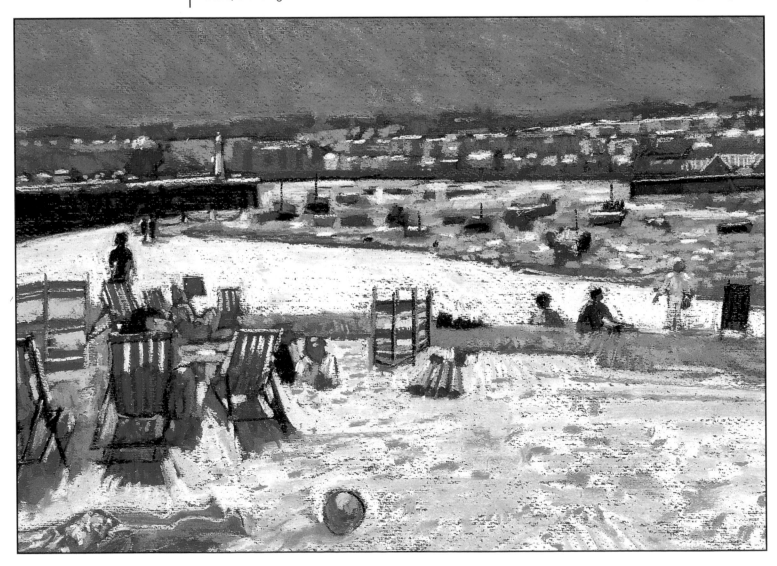

Shadow play with pastels

Shadows have a vital part to play in any sunlit scene. They act as foils to areas of light, intensifying colours and the sensation of heat.

To paint pictures filled with sunlight, it is vital that you appreciate the role of shadows. For, above all, it is the contrast between cool, dark, and yet colourful shadows and warm, bright hues in sunlit areas that creates the overall impression of intense light and heat.

When composing a sunlit scene, remember that either bright OR shadowed areas should dominate: an even spread of lights and darks diminishes the force and dazzle of light. In the demonstration shown here, for example, dark values predominate, yet the total effect is of warmth and brightness.

Another important element in creating the look of sunshine is reflected light. On a sunny day, coloured light is reflected back into shadows from the sky and nearby objects. White objects, such as the Greek buildings in our demonstration, reflect a lot of light, so the shadowed parts contain blue or violet tones reflected from the sky. Reflected light also gives shadows a certain luminosity: you can capture this by lightly scumbling one colour over another, rather than by applying flat, opaque colour.

One very useful tip is to start with dark tones and work up to light ones. Plotting the darkest tones first gives you plenty of scope for working up the middle and light tones; on the other hand, if you start with the lightest tones you have nothing to gauge them against.

Coloured paper is the best option if you want to capture brilliant light. Surprisingly, a mid- to dark-toned paper is a better choice than a light-toned one; it allows pale tints to stand out fully, whereas white or light-toned paper competes in brilliance with the colours you apply, making it difficult to judge the relative tones accurately.

The artist, Jackie Simmonds, chose Sansfix board rather than paper. Its unique tooth is able to hold a lot of pastel pigment, allowing you to build up rich colour combinations without clogging the surface. It also eliminates the need to fix the pastel – either between layers of colour or when your picture is finished.

▶**1** Sketch in the main outlines of the composition with a white Conté crayon (this gives a sharper line than charcoal, and shows up better on a dark surface like this one).

Although this is an outline sketch, it's important with man-made structures that your drawing is accurate – any errors made now will be glaringly obvious in the finished picture. So spend time getting the perspective and proportions right – any mistakes are easily dusted off with a clean rag and you can start again.

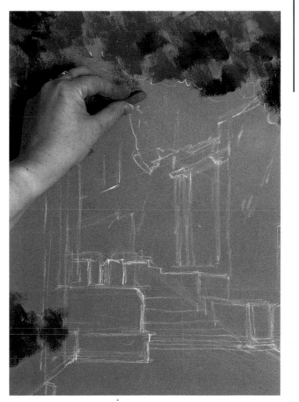

◀**2** Start by roughing in the dark greens in the overhanging vine and the foliage at the base of the wall. This establishes the darkest tone in the picture, giving you something to work against when you begin to build up to the lights.

Snap off short lengths of pastel and lightly stroke the colour on with the side of the stick to make broad, loose marks – don't attempt to draw the leaves in detail. Alternate your colour selection between greenish blue, bluish green and moss green.

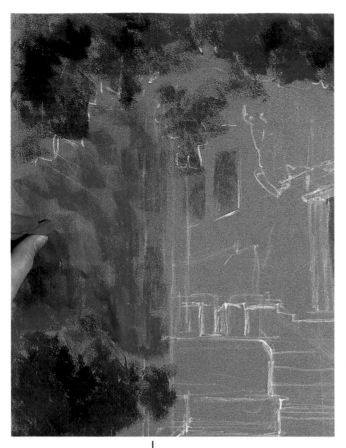

3 Work over the greens with touches of Pozzuoli earth and reddish violet. This strengthens the greens and is a useful way of creating the effect of Mediterranean heat. Using the same loose, angled strokes, work on the wall on the left of the picture with caput mortuum pale, burnt light ochre, and hints of Pozzuoli earth. Allow the colour of the pastel board to show through the pastel strokes.

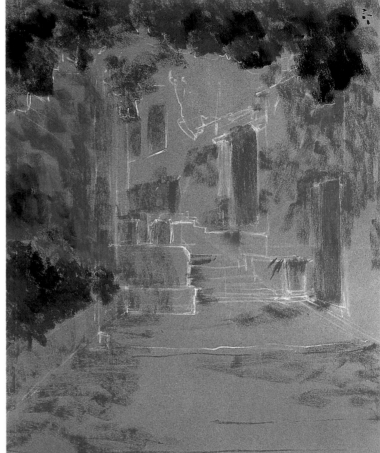

YOU WILL NEED

- A 44.5 x 56cm (17½ x 22in) sheet of grey Sansfix board
- A thin charcoal stick
- A white Conté crayon
- A clean rag
- Sixteen Schmincke pastels: white, burnt light ochre, gold ochre, sunproof yellow deep, Prussian blue, greenish blue, cobalt blue, bluish violet, reddish violet, bluish green, leaf green, moss green, olive green, caput mortuum pale, Pozzuoli earth and neutral grey

4 Snap off a short length of caput mortuum pale pastel and lightly stroke over the doors and windows. Now apply broken strokes of Prussian blue to suggest the areas of dappled shadow falling across the walls and the steps.

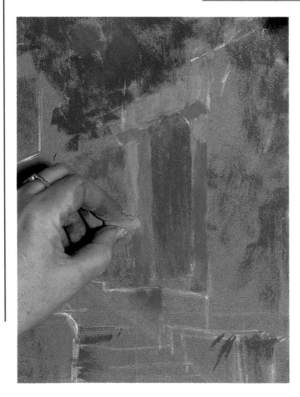

5 Work on the mid tones in the foliage with a warm, mid tone olive green. Then put in the door frames with neutral grey. The juxtaposition of the grey against the brown of the door creates a wonderful, luminous glow that suggests intense heat and strong, midday light.

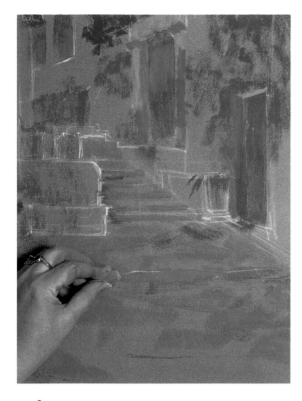

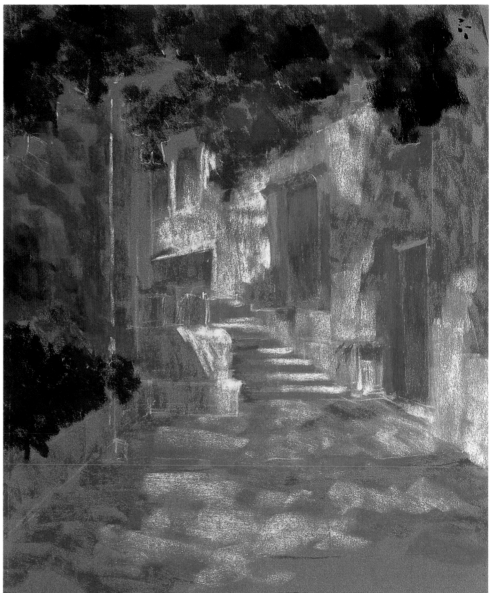

▲ **6** Apply side strokes of gold ochre over the upper part of the middle door, which is struck by direct sunlight. Use the same colour to touch in the front planes of the stone steps. For continuity, add a little gold ochre to the other door and windows and to the shaded wall on the left.

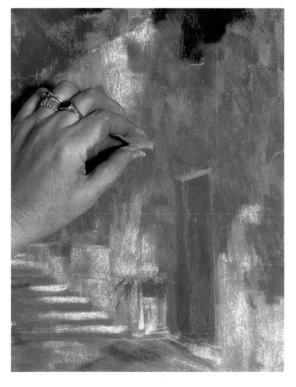

▲ **7** Working lightly, with side strokes, put in the sunlit areas with white. Now is a good time to stand back from your work and check that the balance of lights and darks is working.

Remember, in the early stages your main concern is to establish the underlying tonal structure – the 'glue' that holds the picture together.

◄ **8** Now you can start to lighten and develop some of the shadows to make them more translucent. Do this with loose strokes of cobalt blue, gently breaking it over the underlying colour with light, feathery strokes so the two colours 'resonate', suggesting areas of reflected light.

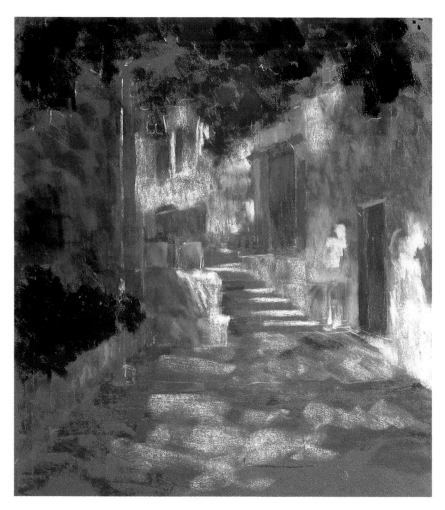

9 Continue working over the picture with the cobalt blue to suggest soft, dappled light breaking up the shadows. Scumble some bluish violet over the browns on the left-hand wall, and touch in some Prussian blue on the steps. Look for subtleties such as the way the edges of the shadows gradually become lighter and softer.

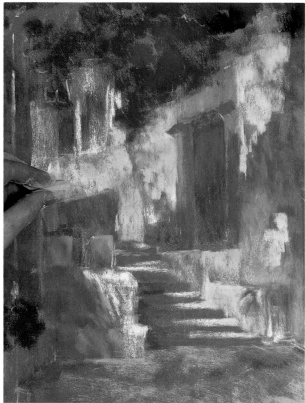

10 Now start to warm up the sunlit areas with touches of sunproof yellow deep. Once again, see how the complementary colours come into play here, the yellows vibrating with the blues and violets. Lay in broad strokes of the same colour in the foreground and the wall on the right.

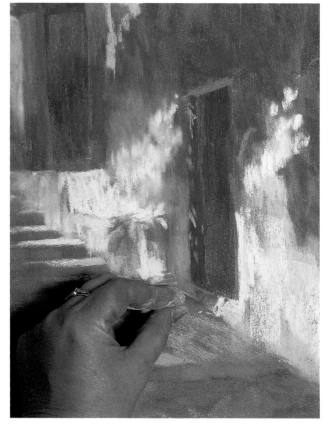

11 With the broad image firmly established, you can begin to fine-tune your picture. Brighten up the sunlit parts of the wall with white, then jot in some dappled shadows on the lower door frame with the tip of the cobalt blue pastel stick.

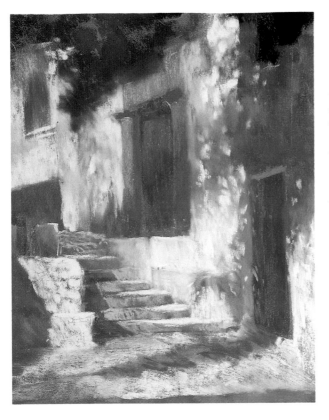

12 To create the sensation of light filtering down through the vine on to the wall, break up the edges of the cast shadows with dappled strokes of white, softening some of the marks with your fingertip. Scumble over the cast shadow of the lower door with cobalt blue, and define the wide bottom step with neutral grey and Prussian blue. Scumble over the ground with sunproof yellow deep and white.

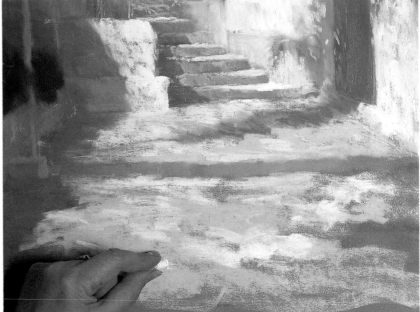

13 Continue to develop the street by applying broad, loosely spaced strokes of white and gold ochre, and overlay these with hints of neutral grey and white. Contrasted with the smaller marks in the rest of the picture, these bigger marks bring the foreground forward, enhancing the illusion of depth.

14 Build up colour and texture in the vine, using sharp-edged pastel pieces to make staccato marks. Use medium, warmish greens for the foliage at the front and cooler, bluish greens to knock back the foliage behind.

15 Suggest the crumbling texture of the wall on the left of the picture with the thin charcoal stick, lightly drawing in a few cracks and fissures.

◀ **16** Finally, use sunproof yellow deep and leaf green to accent the bright, sunlit leaves on the vine. Don't overdo these highlights, though – brilliant spots of colour are more effective when used sparingly.

▼ **17** The pastel is now finished. Notice how the artist has subtly woven complementary colours – blues and oranges, violets and yellows – throughout the picture. Because complementary colours intensify each other, they set up a colour vibration which captures the dazzle of Mediterranean light.

Tip

Drawing a blank
When you're drawing with pastels on a toned ground or support, make sure you leave patches of the paper uncovered or blank. The blank paper – as here, at the foot of the paper – both provides the pastel with an extra tonal dimension and creates a sketchier, more spontaneous look. Plain white paper would have to be covered up or used to suggest highlights.

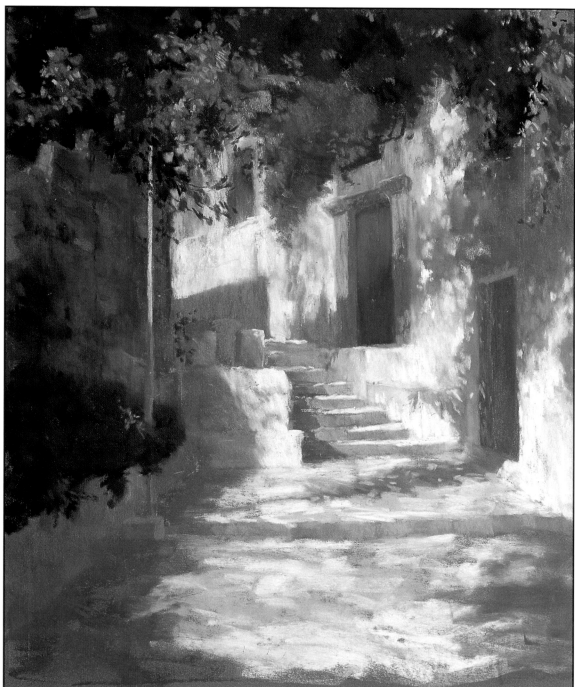

Capturing light and shade

Strong contrasts of light and shade make a fascinating subject within a subject which is particularly attractive to capture in soft pastels.

If you sit all day in your garden on a sunny summer's day, you'll notice how the light changes as the day goes on. Morning light is clearer and cooler than early evening light, throwing shadows which change totally to the opposite direction by the end of the day. Midday light is the strongest, creating small shadows or none at all. Try noting these differences in your picture-making. You'll find that recreating the

light effects of the time of day can bring a scene vividly to life.

Light – or the lack of it – changes everything, including colours. Look at the finished drawing in the following demonstration by the artist, Jackie Simmonds. The foreground grass is rendered in a range of mid and pale bright greens, which turn into cool blues and violets in the shade. Soft pastels are good for capturing these colour variations, since you can apply many strokes of different hues to build up a richly varied area of colour.

Before you begin, consider the amount of light that shines on your subject and the direction it shines from. Which areas are in shadow, and which colours do you see both in areas of light and shade?

▼ The artist chose his subject and planned this composition carefully to get the maximum contrast of light and shade, bringing to life the cool, shady atmosphere of this café scene, and the sunny surroundings.

We can guess the time of day is midday by the position of the shadows – they fall directly beneath the objects that cast them, suggesting that the sun is high in the centre of the sky.

'Perpignon Café' by John Mackie, pastel on paper, 40.5 x 58.5cm (16 x 23in), courtesy of Walker Galleries, Harrogate

Country garden

◀ **1** Working on the smoother side of the paper, establish the main colour areas – violet, blues and greens – with broad strokes, using the sides of the pastel sticks. Gently rub your strokes with a crumpled tissue to soften them and remove excess pigment. You are, in effect, creating a loose underpainting, applying mid-toned greens for the foliage areas and blues and purples for the shadows.

▼ **2** Lightly sketch the main outlines of the composition using a thin stick of charcoal. Carefully construct the shapes of the chair and table, since any inaccuracies in the drawing will be difficult to correct later on.

YOU WILL NEED

- ☐ A 45 x 55cm (17¾ x 21¾in) sheet of pink Canson pastel paper
- ☐ A thin stick of charcoal
- ☐ Spray fixative
- ☐ Tissues
- ☐ A selection of soft pastels, including the following colours (or their equivalents): pale yellow ochre, raw sienna, cadmium yellow, white, Naples yellow, yellow green, cadmium orange, dark blue, cobalt blue, ultramarine, indigo, blue green, blue grey, purple, violet, pale lilac, lime green, turquoise green, sap green, terre verte, viridian, grey green, brilliant green, burnt sienna and madder brown

▶ **3** Start to establish the main clumps of foliage. Begin with small, hatched strokes of violet, working this carefully into the background over the whole picture area.

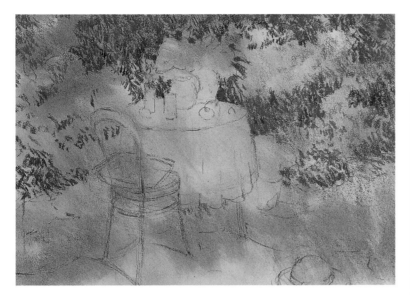

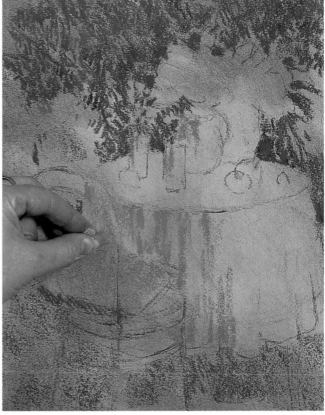

◀**4** The violet provides a mid-tone for the background. Use strokes of burnt sienna for the darks, and blue green for the lighter areas. Build up the foliage slowly, with loose, open marks, otherwise it will quickly become too dense and heavy.

▶**5** Break off a short piece of cobalt blue and with gentle side strokes block in the blue cushion on the chair and the shadowy drapes on the tablecloth. Use the tip of the pastel to touch in some cool blue reflections on the jug and glasses.

Work freely over the image, adding highlights and bright colour accents to key them against the darks. Don't be too literal in your interpretation of your subject, but think in terms of how the colours in the painting relate to each other. For example, this artist introduced complementary contrast with touches of raw sienna that glow against the blues and violets in the shadow areas (see below).

◀**6** Apply Naples yellow for the colour of the tablecloth. Describe the hydrangea bush to the left with small, hatched strokes of viridian and cobalt blue, using turquoise green for the lighter tones. Touch this on to the vase, then use cadmium yellow to pick out light tones around the picture. Use cobalt blue for the hat ribbon.

Block in the cast shadows on the grass with gentle side strokes of violet, then pick out the dark colour of the chair with burnt sienna, applying raw sienna for the lighter colour. Use both raw sienna and cadmium yellow to give form to the oranges on the table.

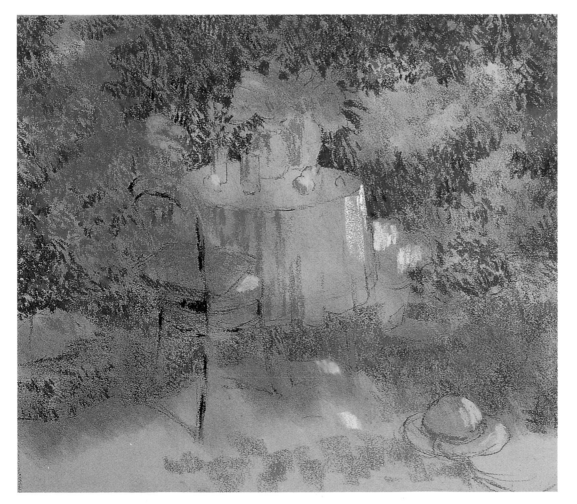

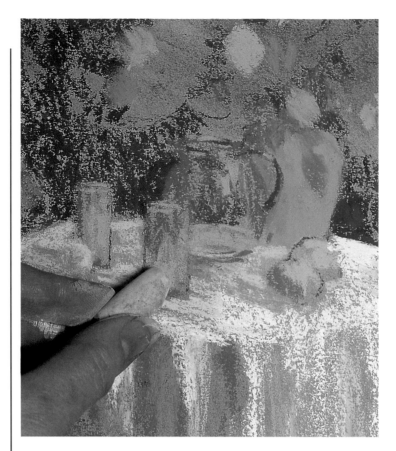

7 Now start to develop the objects on the table in more detail. Use turquoise green for the vase, and outline the jug with purple. Apply a very pale tint of yellow ochre for the highlights on the tablecloth, and icy blue grey for the shadows of the drapes and folds.

Use the same blue grey to add more reflections on the jug and glasses, and to suggest some of the white roses in the jug. In this detail, notice how the pink paper glints through the broken pastel marks, its warmth glowing against the mainly cool colours on the table.

8 Continue to develop the dense mass of foliage in the background with broken, hatched strokes, still using light pressure to avoid clogging the paper. To begin with, stick to cool greens, as the artist does here, then overlay these with strokes of a warmer green such as sap green. The warm over the cool sets up a vibrant effect which suggests the presence of warm sunlight.

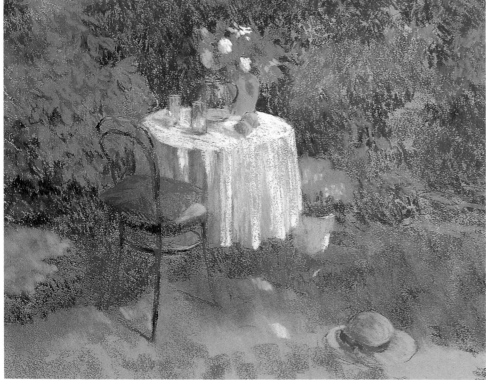

9 Don't be tempted to work for too long on one area, since this will throw the picture out of balance. Work around the whole image, keeping the surface alive at every stage. Here you can see how the artist has set up links between similar values of hue and tone across the image. Warm greens, yellow and ochre are established in the foreground, and touches of warm blue (ultramarine) and cooler blue (cobalt) are echoed on the cushion and the ribbon on the hat.

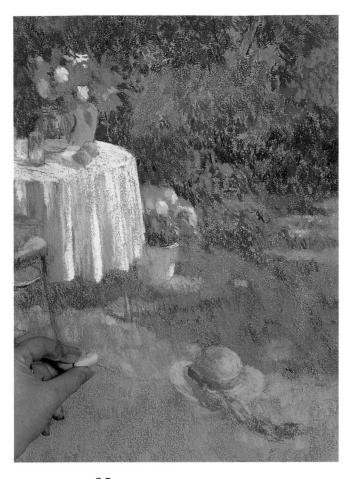

◄ **10** Paint the sunlit patch of lawn in the foreground with scumbled strokes of terre verte and sap green, worked over with yellow and yellow green.

Notice how our artist shows the strong contrast between the areas of light and shade on the foreground grass. The dividing line between them is strong, and the colour of the grass changes dramatically as you cross it.

► **11** The artist used short, upward strokes to build up the foreground grass, blending them a little to soften the effect. The warm pink of the paper shows through the pastel strokes, suggesting the sun-warmed earth peeping through the grass.

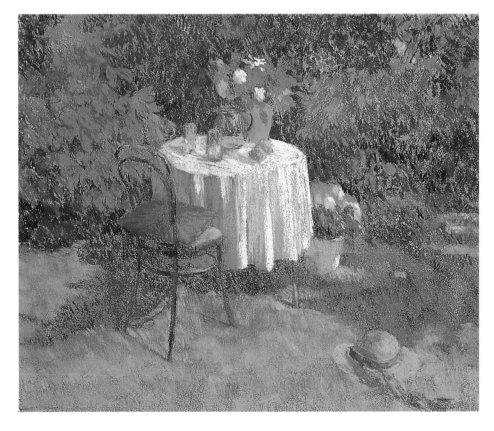

◄ **12** Continue to define the shape of the sunlit area of lawn, using a combination of side strokes and tiny stabbing marks to suggest the clumps of grass. Brush in some hints of raw sienna to soften the greens, particularly around the hat – this helps the hat to blend naturally into the picture, so it doesn't detract from the table, which is the main centre of interest.

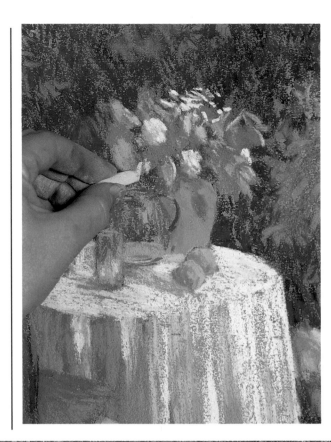

◄13 Now the picture is almost complete. Stand back to judge the overall balance of tone and colour, and make any adjustments necessary. Bring the white roses in the vase into focus with blue-grey and pale lilac for the shadows, and white for the sunlit petals. Dash in some brilliant accents of bright lime green on the sunlit parts of the leaves.

▼14 To finish, intensify the shadow beneath the table with touches of dark blue, and use the same colour to give depth to the background foliage and outline some of the hydrangea leaves to give them form. Then add flecks of warm yellow green to suggest sunlight striking some of the leaves.

In the finished picture, parts of the surface remain open and grainy, so that the soft pink ground comes through and permeates the scene with its warmth, creating a delightful impression of hazy summer afternoon light.

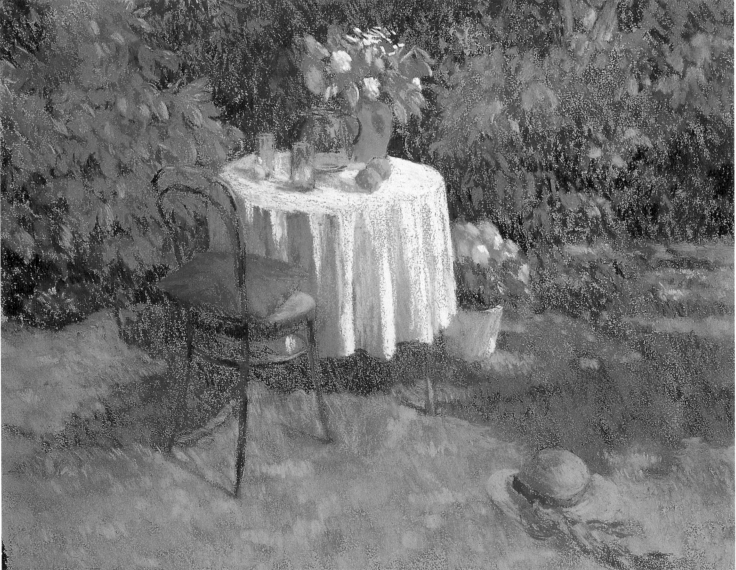

Conveying dappled light

When light is filtered through leaves and branches, it scatters on the ground, creating kaleidoscopic patterns – a breathtaking effect which poses an irresistible challenge to the artist.

For many landscape artists, whether the scene is a field or a forest is, in a way, incidental, because what they are really interested in is the quality of light and the way it plays on the landscape. Capturing the effect of light and the atmosphere of a scene will communicate a mood – it can be soft and restful, dramatic and exciting or lively and energetic, for example.

When sunlight is filtered through trees, it creates a fascinating pattern of light and shade on the trees, shrubs and ground that many artists love to paint. To suggest this, you need to apply small strokes or blocks of colour, being very careful to ensure that the light direction is consistent in all areas.

Painting on location is challenging because the light changes as clouds pass and the sun moves through the sky. There are many ways to deal with this – you can work quickly or make sketches to record particular patterns of light and shade, or you can even commit the scene to memory. Alternatively, you can follow the light around as it changes, constantly adjusting your drawing. This isn't easy, but if you persevere the final image will have a special spontaneity and energy. Working from a photograph is easier because the patterns of light and dark are fixed, but your painting may be disappointingly static.

Make sure you 'key' your tonal values and colour temperatures to fit the mood of the day. In this demonstration by the artist, Jackie Simmonds, the soft, lyrical colours suggest a delicate spring light – quite different to the intense sunlight of summer, which would typically show up fully saturated colours and strong contrasts. The canopy of foliage is thin, so plenty of sunlight can filter down and cast lace-like patterns of light on the woodland floor.

▼**1** Lightly sketch the main elements of the composition in charcoal. Use fairly light, broken lines, working from the base of the trunks upwards to capture the 'gesture' of the trees. When working on the tree trunks, make sure the negative shapes between them are interesting – this will make your composition more dynamic.

▲**2** Start by laying in the broad masses of tone and local colour using broken pastel pieces on their sides. For the grassy banks on either side of the path, lay down patches of a rich red brown, interspersed with areas of dark green and touches of cobalt blue. Soften and blend the strokes with a crumpled tissue. While you have the cobalt blue pastel in your hands, use it to start indicating the sky at the horizon.

YOU WILL NEED

- [] *A large sheet of grey Canson paper*
- [] *Fine stick of charcoal*
- [] *Soft tissues*
- [] *A medium-sized round stiff bristle brush*
- [] *Soft pastels in the following colours: orange ochre, pale and dark cobalt blue imitation, ultramarine deep, grey blue, pale and dark bluish green, greenish umber, moss green, pale and dark May green, light green, mid and dark burnt green earth, neutral grey, ochre light, pale soft pink, pinkish red, yellow green, yellow brown, red brown, dark brown and turquoise*

◀ **3** Begin to suggest the play of light and shade on the path with strokes of yellowish brown and cobalt blue. Use the same pale brown with a neutral grey to jot in some of the shadows on the tree trunks and branches.

Continue to bring out the cool, hazy tones on the distant horizon with very light vertical side strokes of cobalt blue.

▶ **4** Carry on developing the area above the horizon line. Use a pale soft pink to indicate light shimmering through the branches, and a cool bluish green to suggest the umbrella of foliage towards the top of the composition. Blend some of the strokes with your fingertip to give an impression of the soft light filtering through the trees.

◀ **5** Stroke the pink from the background on to the sunlit areas of the trees and the path. Extend the foliage using a broken piece of pale bluish green, flicking in small, broken marks. Then define the darkest shadows on the trunks and branches with linear strokes of neutral grey.

(Notice how the artist tests her colours on the edge of the paper before using them in the drawing.)

◀**6** Use neutral grey and pale pink to draw the young saplings to the right of the picture, making sure you keep the lights and shadows consistent with the light direction you have established. Use the same colours to develop the shadows on the tree branches that stretch out over the path.

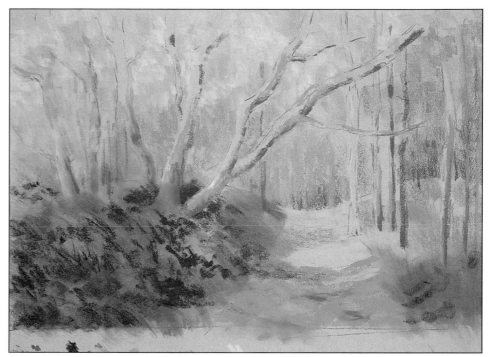

▶**7** Develop the texture of the rough undergrowth either side of the path with scribbled marks and flicks of dark brown and dark, bluish green over the blended underlayer. Put more colour into the shadows on the path with overlaid strokes of umber, ochres, and greys. Let the colours merge into each other to create the effect of the soft, uneven ground.

◀**8** Now you can start to add touches of light which will bring your picture to life. Use a strong yellow green and short, staccato strokes to describe clumps of grass that catch the sunlight as it spills down the bank on the left. Flick in some cooler, paler greens between the sunlit grasses.

Continue to develop the texture of the tangled undergrowth using a range of mid and dark greens, both warm and cool. Use varied marks – scribbles, circular strokes and short, stabbing dashes – to describe the grasses and ferns. Bring more harmony to this area by adding some blended strokes of warm complementary pinkish red amongst the foliage. This breaks through to create an impression of earth and crumbly leaves left over from the previous autumn.

◀**9** Here you can see the way the touches of broken colour are building up – suggesting the variety of the undergrowth and at the same time producing an entertaining picture surface. Notice, too, how the combination of warm and cool colours helps to suggest depth.

▶**10** Define the dappled light and shadows that curve down the grassy banks and across the path using greys, ochres and pale soft pink. Test each colour on the edge of the paper before using it.

 The many strokes of colour make the eye dance about the composition, but it doesn't rest anywhere. You need to provide a focal point, but one that doesn't detract too much attention from the effect of dappled light.

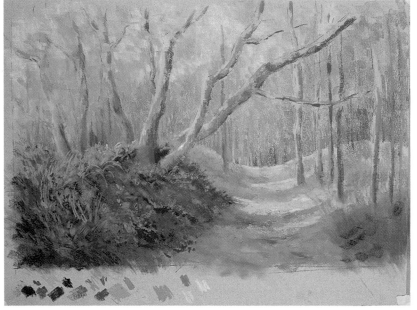

◀**11** For a focal point the artist chose to put in two shadowy figures strolling along the path – notice how they help to indicate the scale of the trees. Use a piece of fine charcoal to draw the figures with quick, sketchy marks – too much detail will make them appear wooden and too important.

▶**12** Describe the undergrowth to the right of the picture using the same range of warm and cool greens as before, adding some of the rich, red brown. Also add a few flecks of ultramarine to enliven the foreground.

13 It's important to work over all areas of the picture at the same time, moving from foreground to background and looking out for the way tones, colours and shapes relate to each other. Add some loose, vertical strokes of cool, pale greens and blues in the background behind the trees, using the chisel edges of the pastels. These soft tones help to capture the sensation of cool spring light and suggest the trees receding into the depths of the woodland.

Switch to warmer, yellowy greens and build up the foliage texture on the foreground trees with short side strokes. Then apply bright chinks of light to the edges of the light sides of the trunks with ochre light.

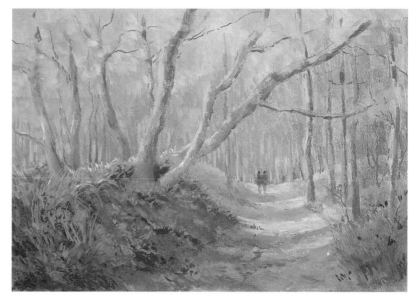

14 Add more saplings on the right and some thin branches at the tops of the trees, using a neutral grey.

With the picture nearing completion, step back and assess what remains to be done. Notice how the bright greens along the top of the grassy bank and the orange ochre across the path brighten the composition. The eye naturally follows these paths of light weaving through the picture.

15 Work along the top of the picture with small strokes of pale cobalt to indicate the sky breaking through the foliage. Then suggest the leaves on the trees with small flicks and dashes, first with a soft turquoise and then with a bright green and an ochre light. Break some of the strokes across the tree trunks to indicate branches coming towards you.

▶ **16** Blend some of the greens and blues in the background with the bristle brush so the area fades into the distance. You want it to sit well back and give the impression of recession.

▼ **17** Add hints of colour on the strolling couple, using red brown overlaid with grey on the woman and cobalt blue on the man. Knock back the colours by rubbing them with your fingertip so they aren't too bright and prominent. Now use the sharp edge of the ochre light to suggest the light catching the edges of the figures.

▼ **18** Complete the picture by adding some final accents of colour around the picture. Flick in some strokes of ultramarine and bright green to enliven the left bank, and add soft touches of pale cobalt on the tree trunks. Finally, add tiny flecks of ochre light for the dappled light on the path and the tree trunks.

In the finished picture, the artist has truly captured the sense of light filtering through the trees and on to the woodland floor. This dappled light instils the scene with a sense of magic and mystery, and the strolling couple add a romantic touch to this successful portrayal of a woodland scene.

Blending soft pastels

By smoothing out and blending in strokes of soft pastel, you can achieve an excellent rendition of distant mist and clouds for a highly finished picture.

There are two schools of thought about using soft pastels. Many artists like to build up a network of individual strokes allowing the grainy, rough texture of the paper to show through. Other artists, attracted by the powdery nature of the medium, enjoy smoothing out and blending pastel strokes for a high degree of surface finish.

In this picture of a Scottish landscape, the artist, Jane Lompard, has made the best of both worlds. She used single strokes for the loch and the foreground where the tooth of the paper is very visible. For the background and the sky, she takes the time to blend strokes together and work the pastels into the tooth of the paper.

In particular, the blending gives a wonderful impression of the soft mists lying on the distant hills, and enhances the atmospheric perspective: the bolder foreground strokes leap forward, while the less distinct blended colours retreat.

When blending pastels, use a large support. If you work on a much smaller scale, you may find that the smudging of the pastel becomes a little imprecise. In this picture, the large scale is also suited to the subject matter – amplifying the sweeping space of the beautiful Highland landscape.

To enhance this sense of space the artist placed the horizon on the bottom third so she could include a broad expanse of sky. Looking across the water and into the cloud-filled sky, the viewer feels almost as tiny as one of the foreground sheep.

With the sky playing such an important part, you need to pay particular attention to the clouds. They are not rendered easily. You want to present them as three-dimensional: occupying enormous amounts of space and overlapping each other. At the same time, you want to give an impression of their intangibility – the fact that they simply consist of vapour.

To do this, it is essential to work with a light touch, as you build up layers of colour. This technique gives the clouds some body without destroying their airy quality. Avoid overworking your first application of pastel, filling in the grain of the paper – the surface will become greasy and subsequent layers of pastel do not hold.

When rendering the clouds, also bear in mind their relationship with the landscape. Look at how the colours and tones of the sky here are balanced by similar colours and tones in the landscape. The dark cloud on the left echoes the dark satanic hill on the right. Furthermore, the lighter yellowish clouds extending across the lower sky pick up on the horizontal stretch of sunlit grass in the foreground. It is interesting to examine also how the artist has introduced many of the colours shown at ground level (in particular the yellow and pink shades) into the clouds above.

▼ **The set-up** The artist made a preliminary tonal sketch on site using soft pencil. The sketch was completed quickly, but it nevertheless established the essential elements of the final composition.

Note how she emphasized the gloomy cloud on the left and the dark, scraggy hills on the right. Leaving the centre third of the drawing much lighter helps to draw the eye into the picture.

◄ **1** Lightly sketch in the outlines of the landscape with the 7B pencil, positioning the distant edge of the water on the bottom third.

Then start on the sky, gently running the side of the pastels over the paper in diagonal strokes moving from top left to bottom right. This will contrast with the strokes for the hills which will run from bottom left to top right.

Begin with purple grey for the darker clouds and pale cerulean for the patch of bright sky. Then add pale yellow ochre for some of the light clouds.

◄ **2** Use the side of your hand to smudge and blend the pastel to achieve the vaporous appearance of loose cloud formations. In particular, try to mix some of the purple grey with the pale yellow ochre – the grey on its own appears a little dead.

▼ **3** Continue building up the sky using pale yellow ochre, yellow ochre, purple grey and pale cerulean. The sky is now taking shape with its wonderful blend of muted colours. Note how gently the pastel has been applied at this initial stage.

◄ **4** Add pale yellow ochre beneath the strip of cerulean sky on the left – don't use white in the sky since it tends to look like cotton wool. Then lightly add some Prussian blue beneath and to the right of the pale yellow ochre. Blend these colours into one another with your fingertips.

Smooth surface
With Ingres pastel paper, it's essential to work on a very smooth surface. Even the wood grain of a table easel could rub through on to the paper, creating unexpected

marks. It's best to put several layers of newspaper between the easel and the pastel paper. This also gives a slightly soft and 'giving' surface, ideal for soft pastels. If there are any creases in the newspaper, flatten them with a warm iron.

▲**5** Establish the distant hills with purple grey and blue grey. Then add pale burnt sienna and pale burnt umber in the low sky, and use your fingers to draw these colours down to the landscape to give the impression of mist coming over the hills.

▲**6** Blend the colours in small areas with the torchon – the far hills for instance. Here the artist is blending blue grey with a little warm grey to distinguish the farthest hill from the nearer ones.

▶**7** Continue building up and blending the blues and purples on the distant hills. Note how the farthest hill is the bluest to give the impression of atmospheric perspective.

For the grassy slope in the foreground, use light sap green. This is a fresh, vibrant colour that leaps forward at the viewer.

8 Overlay pale lemon yellow on the light sap green to indicate the fall of sunlight – this distinguishes the grassy slope from the blue hills behind. Then use the sharp edges of the purple grey and the dark Prussian blue to redefine the silhouettes and base edges of the far hills.

9 Continue overlaying dark and light colour on the clouds to give them more of a three-dimensional appearance. On the lighter clouds, rub in flesh pink and burnt sienna using a circular motion with your fingertips. Later on, these pastels will pick up on the colours used for the beach.

To catch the delicate highlights on the wonderful sunlit cloud in the centre, use the broken end of the pale yellow ochre. Move the point of the pastel around and vary the pressure to make tiny irregular marks.

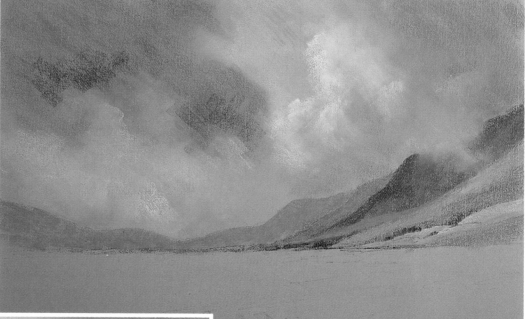

10 Smudge the sky near the horizon with your fingertips so that the clouds appear to be drifting away.

Now turn your attention to the land. Use large sweeps of pale raw sienna to begin the beach. Overlay pale yellow ochre on this where the sunlight falls.

Next begin on the water by running the side of a short pale lilac blue pastel across the paper. Apply this colour very lightly so the tooth of the paper still shows through – this helps give the flickering effect of light glinting on the moving surface of the loch.

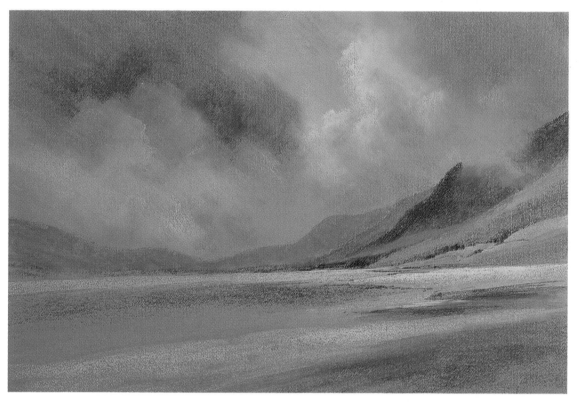

◄**11** Give the water more depth by using long strokes of Prussian blue. Then add broad stretches of burnt umber and dark olive green for the land in the immediate foreground. Overlay grey green and lime green on these colours. Put in the sunlit areas by adding pale lemon yellow.

►**12** Now put in some sheep grazing in the foreground. They don't need to be described too precisely – think in terms of basic barrel shapes. Use pale yellow ochre for the tops of their bodies, and mid grey for their lower halves. Put in the heads and legs with the sharp point of the purple grey pastel. Then all you need to do is put in their shadows with very light smudges of the mid grey – this anchors them to the land.

◄**13** Look around the picture for pastel strokes that are a little too obtrusive and blend them in. Here the artist is using the flat hog brush to spread the colour of the loch a little more evenly. This also tones down the brightness of the blue.

14 Take a last look at the sky and perhaps add a few extra highlights on the creamy clouds. To do this, press the broken edge of the pale yellow ochre pastel firmly enough to reveal the tooth of the paper.

These highlights will probably be a little aggressive so blend the colour with your finger. You can leave the odd crisp edge to help lift the clouds from the sky.

15 Use the same technique on the dark clouds in the sky. See how, by gently caressing the paper with the pastel and lightly blending it, you can capture the vaporous appearance of the clouds.

16 After a final appraisal, the artist thought the foreground was too green. She toned it down with purple grey. To complete the picture, she added a line of pale yellow ochre along the distant water line. This picks up some of the paler tones of the foreground, as well the lighter cloud colours.

The artist didn't fix the drawing since the spray tends to dull the colour and texture of soft pastels. Instead, you can cover the finished work with a sheet of tissue paper and gently press over the whole drawing. This should pack the particles a little more firmly into the paper. Tape tracing paper over the picture for protection if you don't frame it behind glass.

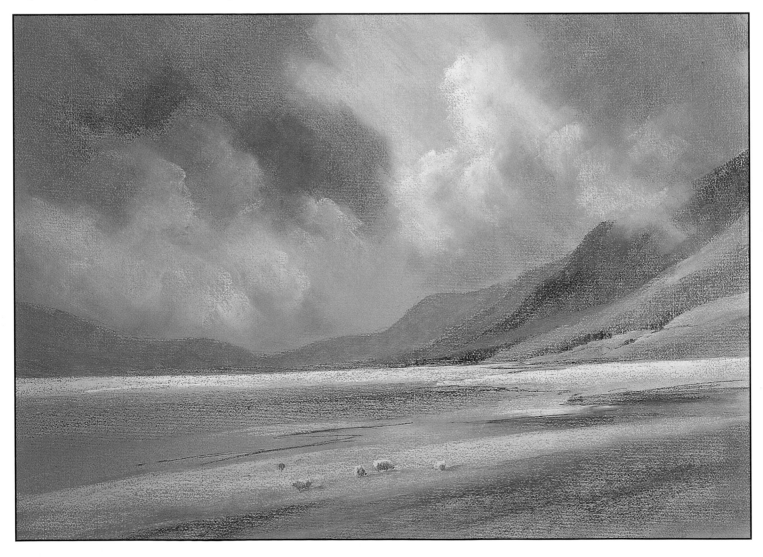

Working soft pastels wet

Expand the versatility of pastels by working with them wet as well as dry. You'll get some exciting results with the water deepening the colours to enrich your pastel paintings even further.

The traditional way of working with pastels is to apply individual strokes of colour side by side, letting them blend in the eye. Alternatively, you can overlay colours and smudge them together on the paper with your fingers or a cloth to create soft colour mixes (see pages 53-58).

But the versatility of pastels doesn't end there. You can extend the use of pastels by mixing them with oil or water to apply them in a more painterly fashion. After all, pastels are basically just pigments in stick form – there is less binder in pastels than in any other artists' medium. So effectively you can use them to make your own paints.

The concept of mixing pastels with oil or water isn't new. In the Nineteenth century, the Impressionist painter Degas tried mixing pastels with other media – sometimes with watercolours, sometimes with thinned oil paint. He created some marvellous pictures in this way, a number of which turned up among van Gogh's effects after his death.

It's probably easiest if you start by mixing pastels with water. Later you can add pastels to your watercolour and gouache paintings. In the demonstration that follows, the artist, Diana Constance, used wet pastels in four different ways. She rubbed dry pastel over wet paper; worked into dry colour with a wet brush; applied the colour from a pastel with a wet brush; and simply wetted the pastel stick and then drew with it on the paper. It's well worth

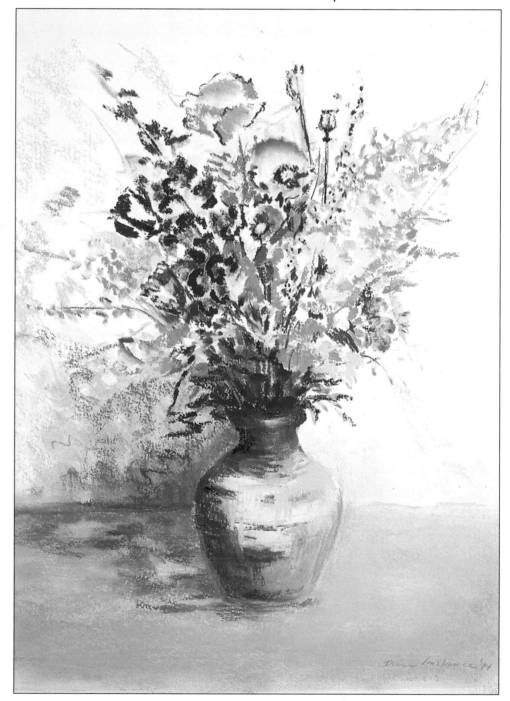

► **Working with wet pastel enables you to create a large range of effects. Notice how the area to the right of the vase, and even the vase itself, look as if they have been rendered with watercolour washes, while the delphiniums could have been rendered with gouache.**

experimenting with all four techniques to discover what interesting effects you can achieve and what you prefer.

You'll find that the water deepens and strengthens the pastel colour by binding the pigment together – it's a bit like wetting face powder or flour to make a paste. And you can push the wet colour around on the paper with a brush, or even remove some by blotting it with a cloth or wiping it off with a wet brush. As a bonus, water helps to fix the colour, though you can still use fixative as a final protection.

The wet paper dries quite quickly under normal conditions, particularly because the chalky pastel soaks up the water very quickly, so keep wetting it as you go along. You can do this by washing over it with a wet brush or simply by spraying it with a plant mister.

Four ways of using soft pastels wet

▲ If you apply a soft pastel stick to wet paper, the colour will flare out slightly, particularly if the pastel is very soft. This flaring is perfect for capturing the delicate tonal variations of flower petals. In fact, the wet pastel behaves a little like a watercolour wash. (Take care not to smudge it!)

▲ When you want to create deep, strong colour in small areas, simply wet the tip of the pastel with a brush dipped in clean water – don't wet the pastel too much or it will crumble. Use firm pressure to apply the pastel to the paper and re-wet the tip after each stroke.

▲ You can create a soft, painterly quality by blocking in colour with a dry pastel and then washing over it with a brush dipped in clean water. Working this way enables you to push the colour around on the paper with the wet brush – and even remove some if required. This is a technique that benefits from practice – try it out on scrap paper first.

▲ The artist is using a 51mm (2in) flat brush here. Simply press a clean, wet brush on to a pastel to transfer some colour. Then press the brush on to the paper to leave a textured print. For fine details you can apply paint in this way with a small brush. Take care not to make the brush too wet or the water will dribble.

Bouquet of silk flowers

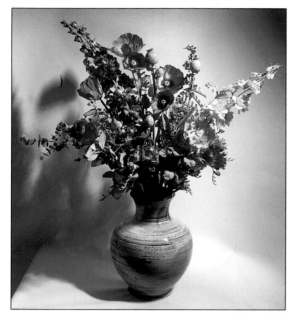

◀ **The set-up** The artist arranged a mixture of silk and dried flowers in a vase, then lit them from one side for dramatic effect. The strong shadows help to place the vase firmly in its setting, otherwise it could look as if it were floating in mid-air.

▶**1** Use your 51mm (2in) flat brush to wet the paper with clean water. While the paper is still damp, sketch the outline of the vase, flowers and shadow with lemon yellow 4, placing the vase slightly to the right to allow space for the shadow.

Go over the shadow with a few strokes of blue green 8 pastel. Now check that you have the correct proportions and are happy with the overall composition.

▲**2** Break off a short piece of indigo 1 and use it on its side to block in the shadow of the vase. Then shade the left side of the vase with the same colour to give it form.

Now use the round brush dipped in water to smooth over the shadow, rubbing it with your fingers to blend in the blue green lines underneath.

◀**3** The artist put in the darkest flowers first, then judged the other colours against them. The first colour used was mauve 5 to block in the purple delphiniums. For the darkest tones of the delphiniums, dab the pastel with the wet brush and press the tip on to the wet paper.

Now use rose madder 0 and 2 to block in the pink poppies, then blend the colours with a wet brush. To sharpen up the edges of the flowers, work around them with pink Conté, making strong, dancing lines.

YOU WILL NEED

- ☐ A 56 x 38cm (22 x 15in) sheet of 200lb Rough watercolour paper
- ☐ Water; kitchen paper
- ☐ Two brushes: a No.12 round; 51mm (2in) flat
- ☐ Two Conté pastels: pink, mineral green
- ☐ Eighteen Rowney soft pastels: Vandyke brown hue 8, sap green 5, grass green 4, Hooker's green 5, blue green 8, viridian 1, cerulean blue 4, French ultramarine 6, indigo 1, mauve 5, rose madder 0, 2 and 6, poppy red 6, cadmium tangerine 2, lemon yellow 4, yellow ochre 6, white
- ☐ Rowney indigo 3 square pastel

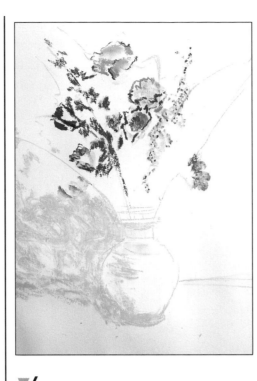

◀ **4** Don't get bogged down with detail; keep the marks varied. Touch in some French ultramarine 6 to the centre of the poppies to give them more form. To lead the eye around the painting, use the colours elsewhere as you see them.

Re-wet the paper and block in the roses on the left with poppy red 6, then use the mineral green Conté to draw the stem of the tallest rose.

▼ **5** Indicate the curve of the freesia stem with lemon yellow, then dot in the freesia flowers with rose madder 6. Stand back to check the overall effect of the drawing. Our artist thought the lowest rose was too red, so she lightened it by lifting off some colour with a wet brush.

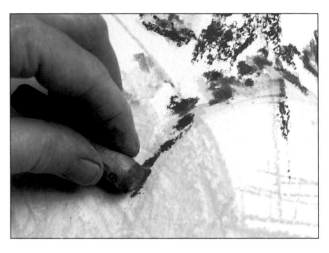

▼ **6** Now turn to the white delphinium. Re-wet the paper, then pick out the flower centres with cadmium tangerine 2; use indigo 1 for the shadows. Blend the colours with white.

Leaving the colour of the paper to indicate the petals, work around the flowers with Hooker's green 5. Effectively, you are putting in the negative spaces around the petals.

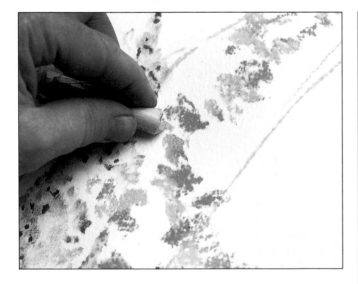

▶ **7** Wet the paper on the vase and dampen the 51mm (2in) flat brush. Press the tip of the brush on to the rose madder 2 pastel stick, then press it on to the vase to make a slightly curved line (see the fourth technique on page 108). Do this a few times, then repeat with some indigo 1.

Lightly apply viridian 1 over the green around the white delphinium, working it in with the wet round brush, and introduce some on the rim of the vase to suggest reflected colour. Use Hooker's green and viridian at the base of the purple flower just below the delphinium.

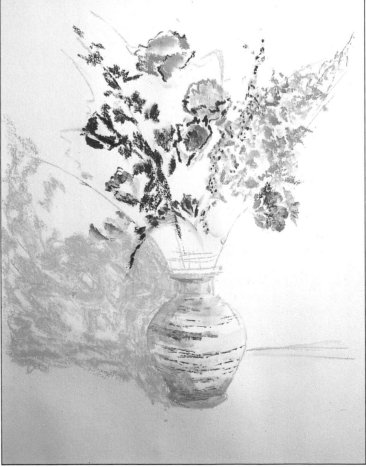

► **8** Stand back again to view your painting. Our artist found the purple delphinium too dominant, so she brushed over it with water and then rubbed it with her finger to remove some colour. Then she applied some indigo 3 to give the petals more depth.

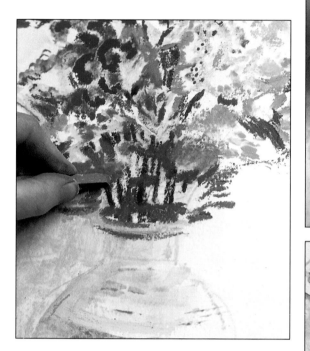

▲ **9** Take some grass green 4 on to your wet round brush to paint in the eucalyptus on the left. Use the tip of the same pastel for the darker leaves and add other greens if required.

For the stems emerging from the vase, apply sap green 5 on its side, blending the colours with your wet brush. Go over the stems with the mineral green Conté, then use the same green to shape the lip of the vase.

► **10** Gently colour the vase with the side of the lemon yellow pastel. Then scribble in some sap green, cadmium tangerine and more rose madder 2 to give shape. Lightly blend the colours with your fingers, then work over the darker side of the vase with indigo 1, scrubbing it into the shadow with your fingers. Darken the base with yellow ochre 6.

◄ **11** Add any final details before going on to the foreground and background. Wet the 51mm (2in) brush and lift some colour from the sap green pastel. Flick the colour on to the foliage on the right and around the eucalyptus on the left. Then stroke several of your greens between some petals to suggest leaves and stems.

Tip

Quick spray
A quick way of wetting your paper is to spray it with water from a plant atomizer. If you only want to wet certain areas of the picture, simply mask out the areas you wish to protect with pieces of kitchen paper. But don't worry if you haven't got an atomizer, just wet the paper with a large wet brush, being careful not to move the paint around too much.

▲12 Re-wet the foreground and add some lemon yellow. Work over it with your 51mm (2in) brush, merging it with the shadow. Smudge some blue from the background into the yellow on the left of the vase and blend in some grass green. Merge a touch of poppy red just under the vase and highlight the vase with white. Use kitchen paper to lift off excess colour.

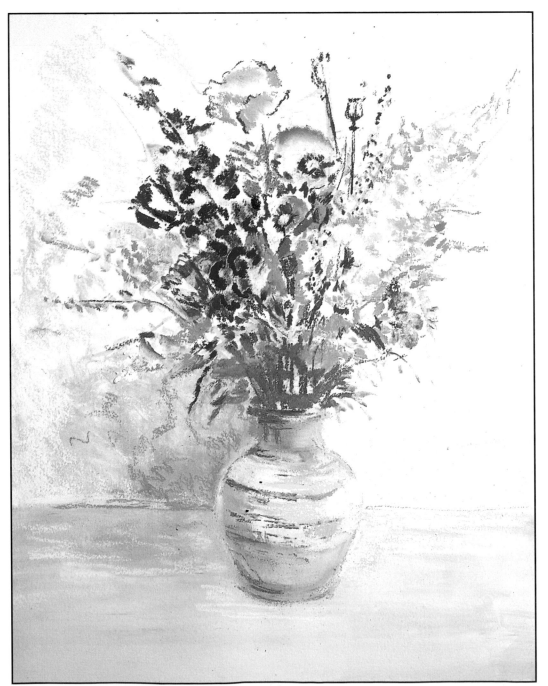

▲13 Leave your picture to dry so you can see the final effect – you can use a hair dryer to speed things up if you wish.

Now squiggle in some cerulean blue 4 across the shady part of the background and run a line across the concealed edge of the table. Touch highlights into the background areas with a short piece of white.

◀14 Make any final adjustments you think necessary. The artist put in the dried poppy seedheads with Vandyke brown 8 and used the same colour elsewhere for balance.

After thinking about the overall colour relationships of the drawing, the artist decided to change the yellow base colour to blue, so she went over it with indigo 1, adding cerulean blue 4, mauve 5 and French ultramarine 6 in the shadows (see the opening picture). She also worked on the vase, strengthening its colours to make it look more three-dimensional.

You can see how wetting the pastel has strengthened the colour while still retaining its soft, chalky quality. Where the tip of the pastel has been pressed on to the paper – such as on the purple delphiniums – the colour is deep and strong. Elsewhere it is pale and ethereal, with a soft-focus effect.

Pastel on prepared paper

Prepare your own grainy, lightly textured pastel paper and lay successive layers of pastel colour over it to create some fascinating, tactile surface effects.

Preparing your own pastel paper is a relatively easy process, and enables you to create a very particular kind of pastel drawing. The focus of this sort of work is texture, whatever the subject – a still life, portrait, or landscape. The aim is to provide a grainy ground for the layers of pastel colour laid over it; the 'ground' (whether this is scattered sand, powdered pumice or pigment) will show through the pastel layers and increase the tactile quality of the picture surface.

To prepare your own drawing surface all you need is a sheet of thick pastel paper, boiling water, some sand, pumice powder, or other gritty substance suitable for adding texture, and a sizing product such as acrylic gesso. Once the ground has been laid down, the picture is built up gradually, using layer upon layer of pastel colour. You may want to create a smoother finish in some areas as our artist does, using a wet paintbrush to dilute the pastel pigment.

▲ Add some water to a sizing product such as acrylic gesso. Ensure that this is mixed well to a creamy consistency.

▲ Scatter powdered pumice over the stretched paper, using your forefinger and thumb to crumble it up into small pieces.

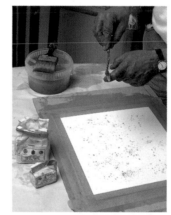

▲ For a toned ground, scatter your chosen pigment over the paper surface, or crumble some colour from a pastel stick.

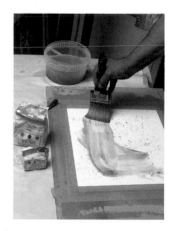

▲ Spread the sizing solution over the pumice and pigment, using broad, even strokes of the decorators' brush. Leave to dry.

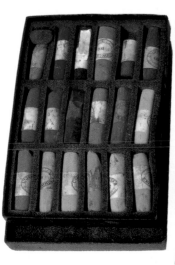

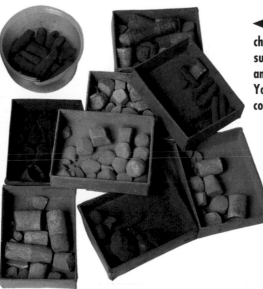

◄ Think carefully about which colour to choose for toning your ground. Keeping your subject in mind, look at your pastel collection and consider each possibility of colour and tone. You can experiment by combining a couple of colours for a unique result.

YOU WILL NEED

- ☐ *A3 pastel paper*
- ☐ *A sizing product; powdered pumice; golden ochre pigment*
- ☐ *Water and pan*
- ☐ *Thin stick of charcoal*
- ☐ *Decorators' brush and a large flat brush; clean rag*
- ☐ *Eleven soft pastels: white, yellow, light ochre, terracotta, light blue, cobalt blue, olive green, dark green, Venetian red, light grey, dark grey*

The Ronda Valley, Spain

This view of the Ronda Valley by Mike Pope is an excellent example of the effects you can achieve on prepared paper with extensive pastel layering and texturing. Two-thirds of the picture space is occupied by the sandy hill with its winding paths; the slightly gritty ground textured with the powdered pumice and ochre pigment provides an excellent representation of the sandy hillside, showing through the heavily worked, layered pastel to make the scene more convincing.

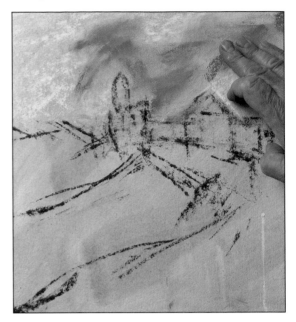

▶ **1** Prepare the paper following the instructions on the previous page. Use charcoal to draw in the main elements of the composition. Lay patches of cobalt blue and white over the sky, then blend the colours together with your fingertips or a clean rag.

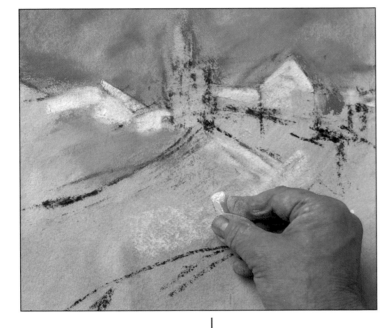

◀ **2** Begin to block in the foreground hill and the houses on the horizon with the side of the white pastel. Add some dark grey here and there on the buildings, mixing it slightly with the white. Begin to lay in light ochre on the upper left sections of the hill.

▶ **3** Work some olive green into the cypress tree and into the greenery beside it. Touch in the house on the far right with dark grey, and work smudges of it into the higher sections of the sky. Use the same colour to darken the shadows of the bushes and foliage.

Roughly and loosely block in a thin layer of terracotta over the hillsides.

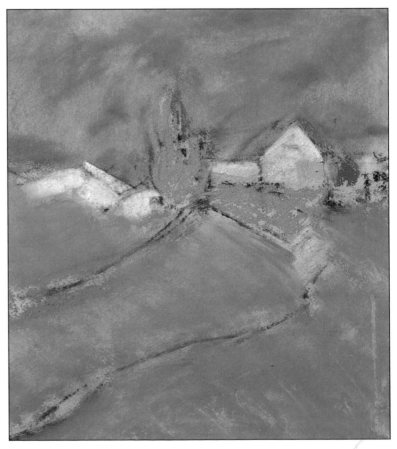

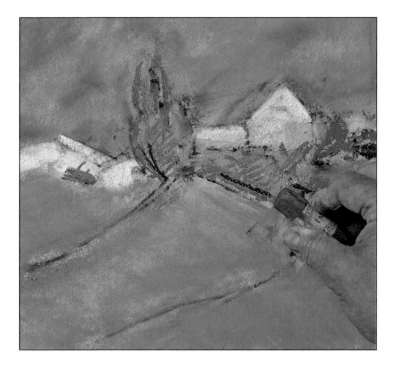

4 Delineate the lower edge of the cypress and foliage beneath the houses with lines of cobalt blue. Continue to darken them, using a cross-hatching of dark green.

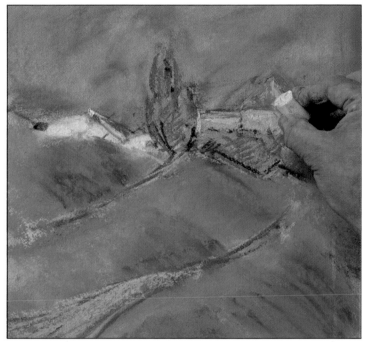

5 Work terracotta into the roofs. Scumble more white over the top of each roof – this will create a convincing impression of the intense Mediterranean light reflecting back from the roof tiles.

Stroke some light blue and white on the paths leading up the slope. Add some strokes of Venetian red to the hills for rich, deep shadows.

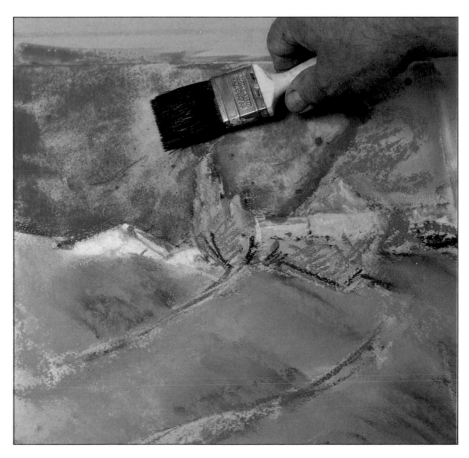

6 Load the decorators' brush with water and paint across the sky, making a wash of the cobalt blue pastel there. When the washy blue is dry, you will be able to add another layer of cobalt blue pastel to this area, intensifying the colour and giving the sky a sense of depth.

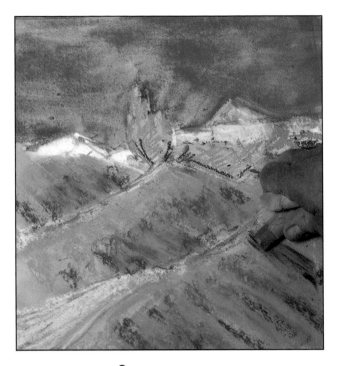

7 Build up the texture of the foreground slope with broad, flat diagonal strokes of the Venetian red pastel. Work some more white and light blue into the main path leading up the slope, adding touches of light grey here and there.

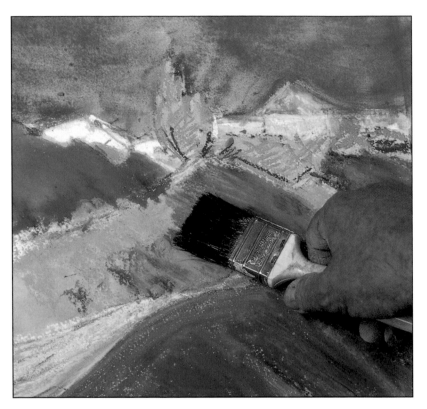

8 Load the decorators' brush with water and wash over the red of the foreground slope. Leave this to dry and then repeat the process. Notice that with this kind of layering you can build up a wonderful powdery surface texture – perfect for representing earth or sand.

9 Continue to work on the sky, using broad, diagonal strokes of the cobalt blue pastel. Add a tinge of light grey to the walls of the house on the right. Scumble some light ochre over the Venetian red on the slope, mixing it in here and there with your fingers or a clean rag. Work into the foliage once again with dark green.

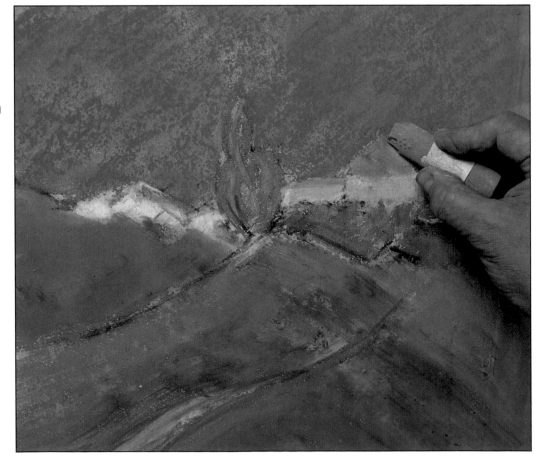

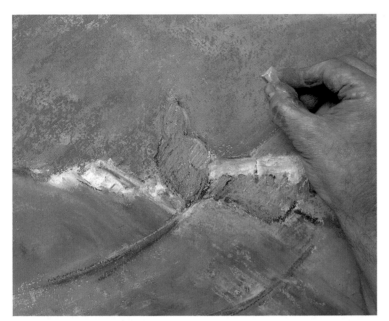

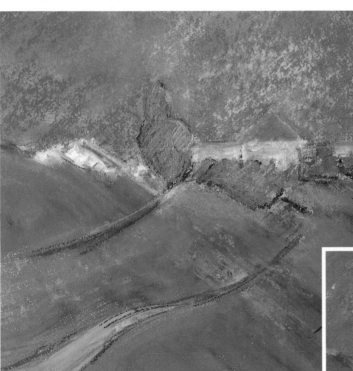

◀**10** Using the side of the light ochre pastel, scumble over the blue of the sky to create an impression of hazy cloud.

Work some diagonal strokes of light ochre into the slope and delineate the small path in the upper left with Venetian red and light ochre. Add touches of cobalt blue and yellow to the foliage below the houses.

◀**11** Work some light grey and white into the larger path leading up the slope, and scumble white into the sky above the house on the right.

▶**12** Work fine diagonal strokes of yellow into the foliage to give it more definition. Use cobalt blue to emphasize the areas of shadow under the foliage. (Remember that the light source is located to the upper right of the scene.)

Load the large flat brush with water and use broad diagonal strokes to wash over the slope once again.

Tip

Steam power
When you've finished your pastel drawing, you'll want to fix it to prevent any

accidental smudging in the future. There's a way to do this that doesn't involve chemicals or spraying. Hold the support over a boiled kettle and let the steam react with the size on the paper, literally gluing the colours in place.

13 Use the tip of the terracotta pastel to work on the upper portions of the sandy slope. Mix in some strokes of light ochre here and there to highlight these areas even more. Stroke in some right-to-left slanting lines of white into the sky. These counterbalance the lines on the landscape which slope the other way.

14 Focus now on the group of houses and the foliage, working with more terracotta and white on the former and with more cobalt blue and yellow on the latter. Add touches of light grey to the tops of both paths.

15 The picture is nearly complete. For the finishing touches, delineate the houses and foliage more clearly with some fine lines of white, and use a clean rag or your fingers to mix the yellow and green in the foliage. Lastly, use the rag to mix together the colours of the large path. This gives it a smooth finish which contrasts with the powdery surface of the parched earth and leads the eye to the focal buildings on top of the hill.

Lilies on rough paper

The abrasive quality of a sandpaper surface makes it an excellent support to choose when you are working in pastel.

With sandpaper – a rough surface – you can work in a much bolder way than with finer papers. The tooth of the paper grips the pastel powder, helping you to build up rich colour and tone by overlaying colours. The amount of colour you lay down depends on just how hard you press. With finer toothed papers much of the pastel falls away, whereas with sandpaper more is held by the surface.

By working the pastel on its side, you'll find the surface of the sandpaper gives variously fine and delicate or rough and coarse textures, according to the grade you are using. The finest grade – 00 sandpaper – is known as flour paper and can be bought from a hardware shop. It comes in small sheets, but if you wish to work larger, you can get big sheets of good quality flour paper from specialist art shops.

A drawback with sandpaper is that it's difficult to erase marks from it – you can lift off some of the paler colours with masking tape, but the stronger colours can only be modified by overworking in a different colour. Using abrasive paper is a unique experience, so try out both soft pastels and hard pastels before you begin.

▶ **The set-up** The artist, Diana Constance, selected a vase of lilies as her subject. She decided to leave out the vase and make a tight composition from the flowers alone, bringing them in closer together and omitting some of the leaves.

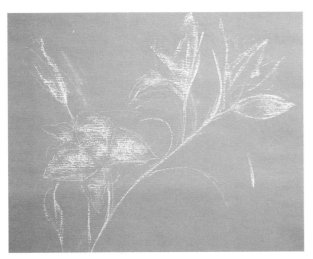

◀ **1** Sketch your subject in Naples yellow Conté – drawing up through the stems and making the flowers as large as possible. Working loosely, lightly block in all the petals with a shortish piece of alizarin crimson light. Hold a small piece of lemon yellow light firmly by the edge to work on the bud and the lines on the petals, running it down the arc of the stems. (Blocking in the flowers first avoids smudging.)

▶ **2** Position the leaves using sap green light. Intensify the pinks with alizarin crimson medium and darken areas of the petals with ultramarine light and mauve light. Use chrome green medium and sap green medium to run veins through the petals and bud and into the stems. Start on the background, using the flat side of a piece of burnt orange medium and work around the flowers and leaves, picking up the texture of the sandpaper.

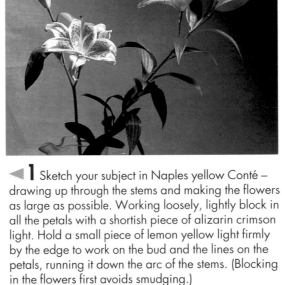

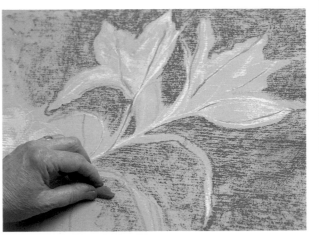

Different strokes

▲ Use a short length of pastel on its side to fill in small blocks of colour such as the lily petals shown here.

▲ To create thick lines, as for the flower stems, drag the side of the pastel lengthways over the paper.

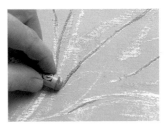

▲ For finer lines, use the side of the pastel tip, turning it as it blunts so that you are always working with a sharp edge.

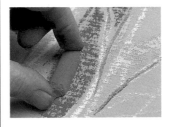

▲ For large areas of colour, such as the background here, use a longer piece of pastel on its side.

◄ **3** Using indigo deep, work on the negative space around the flower (top right) – darken the tone but let the warm orange show through.

Travel across the picture, lightening tones simply by using less pressure, and refining the shapes. Work round any undrawn leaves with burnt orange medium before you lose them. Highlight the petals in yellow ochre light and lemon yellow medium and deepen their shadows with grey medium. Strengthen the pinks with alizarin crimson medium Conté.

YOU WILL NEED

- A 45.75 x 56cm (18 x 22in)sheet of 00 sandpaper/flour paper taped to a drawing board
- Masking tape
- A table easel
- Spray fixative
- Four hard square Conté pastels: Naples yellow, sap green, red oxide and alizarin crimson medium
- Twenty-four soft pastels (a mixture of Schmincke and Rembrandt): alizarin crimson light and medium, madder lake deep, mauve light, violet medium, cadmium orange light and medium, burnt orange medium, grey light and medium, sap green light and medium, chrome green medium and deep, indigo deep, permanent green medium and deep, ultramarine light and deep, yellow ochre light, lemon yellow light and medium, white, coral light
- Unison lemon yellow

► **4** Intensify the stems and leaves with permanent green medium, overworking darker areas in chrome green deep. Add sap green medium to the bud, with permanent green medium for its darker underside. Highlight with white here and on the closest flower. Fill in a few more leaves in sap green medium.

Feather in some Unison lemon yellow on the middle flower, and apply indigo deep for the petal shadows. Vary the lopsided petal with grey light and coral light. Fill in the highlights on the petals with white.

◄ **5** Enrich the leaves with permanent green deep/chrome green deep, then grey light for the paler patches. Emphasize the sheen and turn of the leaves with touches of ultramarine light and lemon yellow light.

Now for a dash of intense colour – use madder lake deep and cadmium orange medium for the velvety sheen of the bright stamens; overwork the shadowed ones in violet medium.

Using the side of the burnt orange medium, work over the remaining background. Lighten the left side with strokes of cadmium orange light, blending it with the side of your fingers.

► **6** Now you can begin to work on the focus of the drawing – the main flower. Edge the petals with yellow ochre light and cadmium orange medium for the very centre. Pull out from the centre in flat strokes with the side of a short piece of alizarin crimson medium. You are aiming for a real sense of depth in the flowerhead.

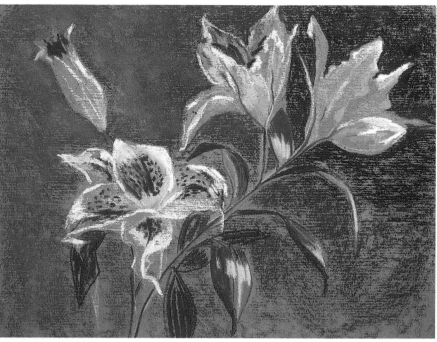

▲ **7** Put in some dark stripes of madder lake deep for the curve of the petals. With the tip of the pastel put in the speckled areas, blending some with the side of your finger.

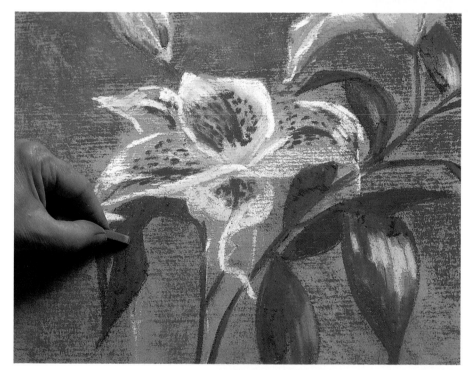

▲ **8** Staying with the madder lake deep, draw in the stamens emerging from the closed flower, adding some cadmium orange medium as you go. Colour the lower half of the flower with alizarin crimson light. Now go back to the main flower and highlight the petals with white to define the shapes.

The artist decided the stems needed extra stress to suggest stronger support for the flowerheads – so she added more leaves for balance.

◄ **9** Block in the new leaves with permanent green medium using quite a bit of pressure. Work over *all* the leaves with sap green Conté – it varies the colour and allows you to run sharply up into the veins of the flowers and bud. Use hard, thick strokes to define the edges.

Go back to the closed flower and work down the side of it with mauve light.

► **10** Put in the stamens of the main flower with madder lake deep and cadmium orange medium, darkening some of them with the red oxide Conté. (All the stamens had actually fallen off this flower so the artist drew them in using her imagination.) Darken the tip of the pistil with red oxide Conté.

▶ **11** Take a look at the drawing and decide if you need to adjust the balance of colour and tone. Go over the background on the left with cadmium orange medium to make it more colourful. Lessen the pinkness of the closed flower by merging in some sap green light.

▼ **12** Add touches of white highlight to the main flower and work through the background with cadmium orange medium and indigo deep, weaving your way through leaves, stems and flowers.

For the final touches, add a little ultramarine deep, blended slightly, to the upper right area. Add some sap green light to the leaves, with touches of white highlight. Merge these with the side of your finger. Finally, spray the drawing lightly with fixative.

In this bold and yet delicate drawing, the rough, scratchy background gives depth and the smooth sheen of the leaves contrasts with the soft, feathery petals. The bright stamens and petal markings add a brilliant shock of colour to the drawing.

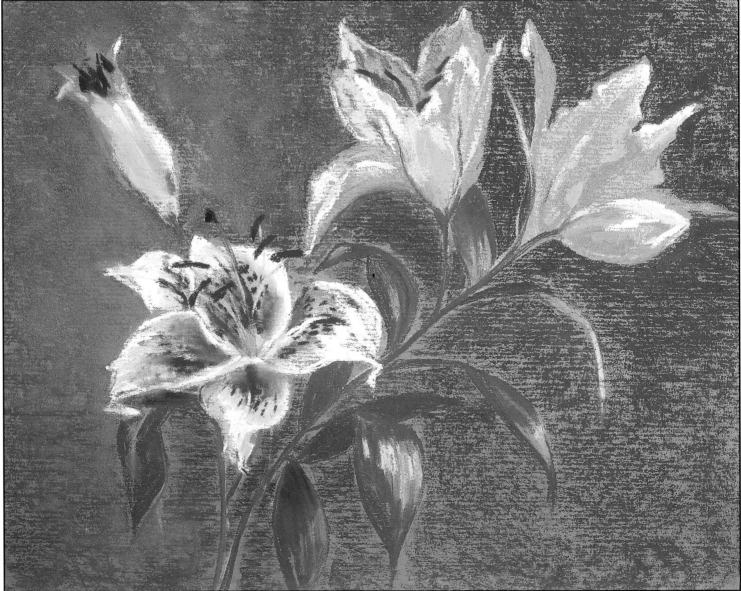

Working on black paper

Starting with a black ground serves to throw the brilliant colours of soft pastels into stark relief – and also helps to highlight the interplay of colour and shape.

When you think of a picture drawn with pastels, what often comes to mind is a delicate image on a muted ground. However, when you want to produce a bolder, more adventurous image, try using intense colours on a black ground so that the colours appear to leap out at the viewer.

A bowl of fruit provides an appropriately colourful subject matter for this type of picture. For the artist here, Frances Treanor, the fruit is only a starting point – she was not so much concerned with obtaining a particularly life-like representation as in producing an exciting play of colour and shape. Consequently, she chose the most vivid colours from her selection, and juxtaposed contrasting colours to obtain a vibrant effect.

This effect was enhanced by rendering most of the fruit in solid blocks of colour with crisp edges.

Pressing hard with the pastels, she used strokes that followed the outline of the fruit. Only on some, such as the apple and the bananas, did she create a sense of three-dimensional form by overlaying colour and varying the tone.

The set-up The artist selected both plastic and real fruit in a variety of colours and shapes and arranged them on a plate-like basket which gave extra interest to the textural qualities of the set-up.

The floral fabric on the tea-cosy in the background provided her with a further opportunity to experiment with colour and pattern.

1 Outline the fruit basket lightly with the edge of a new white pastel (it gives a sharp line). Then begin on the fruit, pressing hard for bold, solid colours. Use lemon yellow to fill in the lemon. Start on the grapes in reddish purple, then move on to mauve. Although the grapes are all a similar colour, you can achieve a more exciting effect by exaggerating and varying their hues. Use lime green to put in a white grape.

2 Carry on with the grapes, using pink violet on some to vary their colours further. Fill in the orange with strong curved lines of both cadmium orange pastels. Use lime green for the apple, overlaying it with cadmium red for the rosy side.

▶ **3** As with the red grapes, vary and heighten the colours of the white grapes using several different greens. Don't worry about pastel dust falling off the paper since this can be worked in later. If the picture becomes too powdery, lightly spray fixative over it.

YOU WILL NEED

☐ A 61 x 45.75cm (24 x 18in) sheet of Ingres or Mi-teintes black pastel paper

☐ Drawing board

☐ Spray fixative

☐ Twenty soft pastels: white, lemon yellow, Naples yellow, yellow ochre, medium and deep cadmium orange, flesh pink, brown pink, cadmium red, reddish purple, mauve, pink violet, turquoise, French ultramarine, lime green, light sap green, emerald green, burnt sienna, burnt umber, pale grey

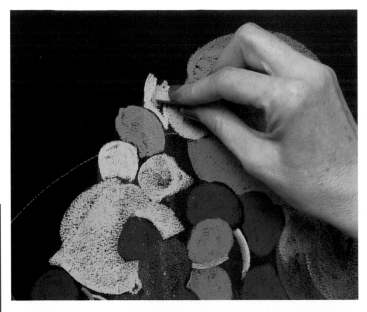

▼ **4** Use deep cadmium orange and lemon yellow overlaid with cadmium red for the tangerine and plastic tomatoes on the left. Add some stems with the sharp edge of a pastel to fill in the spaces between the fruit. The fruit on the basket is now almost complete, appearing as a bright, interlocking pattern of colours.

Notice that the colours don't obliterate the black support – it shows between the fruit. The black also modifies the colour, creating a broken-colour effect and suggesting subtle tonal variations on the surfaces of the orange and apple, for instance.

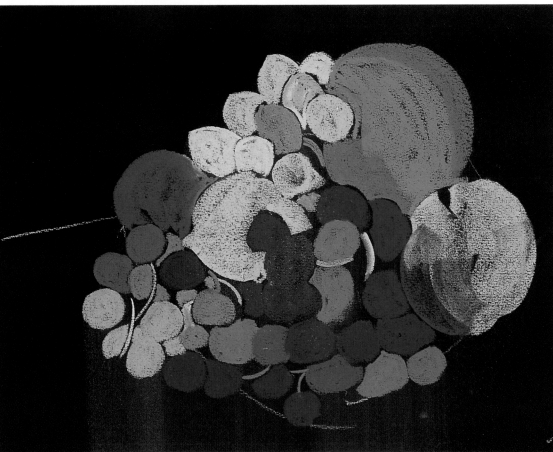

▶ **5** Render the intricate pattern of the basket in repeated strokes of yellow ochre – for this choose a short piece of pastel (or break off a short piece) and use the side of the stick. Do the same with burnt umber to give the basket a dark border. Go over it with a flesh pink to give it a bit of form.

6 Add some of the fruit lying to the side of the basket. Work in Naples yellow for the banana, with touches of lemon yellow for the highlights. (The broken veil of colour implies texture and tone.) Also use the lemon yellow for the grapefruit, drawing its outline first then filling it in with neatly scribbled colour.

7 Before starting on the background use a light spray of fixative on the fruit. This helps preserve the purity of the colours, and stops smudging while you work on the background (see Tip below right).

To make the fruit really stand out, run pale grey pastel around the edge of the basket, using sweeping marks with the side of the pastel.

8 Begin adding a variety of colours to the background – blues, pinks, and yellows. Avoid strong colours or pronounced marks – this will distract attention from the fruit. Go for a simplified suggestion of what's there.

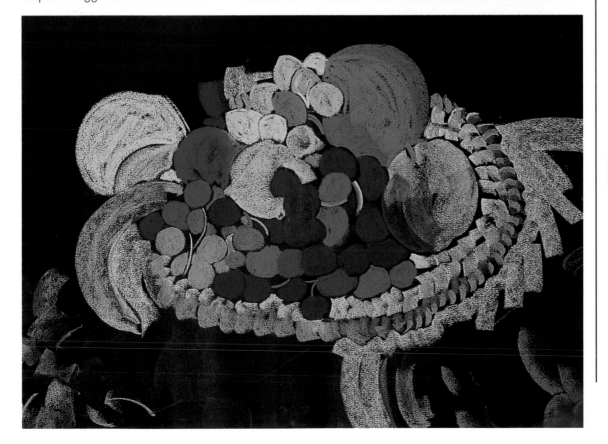

Pattern-making

While some artists are relentlessly literal, others focus on mood or, as here, on the abstract pattern-making qualities of the subject. This artist has deliberately exaggerated and simplified colour, while playing down or ignoring descriptions of form and spatial relationship.

The grapes, for instance, are drawn as single patches of brilliant colour without any attempt to describe the light travelling across the form. Furthermore, the patterned fabric appears to be on the same plane as the fruit. There are none of the differences in colour, tone, texture or detail which suggest recession.

The result is an entertaining and highly decorative jigsaw of shapes and colours. This approach is probably best exemplified in the work of Henri Matisse.

Tip

Successful fixing

The secret of fixing is to spray lightly. Too much spray darkens colours and merges the pigment particles, thus 'muddying' textures. Try using successive light sprays during the course of your picture-making. This allows you to overlay colours while keeping the marks and hues clean and separate.

◄**9** Using the brown pink pastel, start on the floral pattern of the tea cosy. Add spots of emerald green for the foliage with touches of turquoise and burnt sienna.

▼**10** Block in the rest of the background with French ultramarine, using broad marks made with the side of the stick. This dark colour helps to temper the intense black of the paper.

▼**11** As a final step, add some lemon yellow marks to the bottom of the picture to echo the colour of the grapefruit and lemon. The bowl of fruit has now been turned into an arresting array of colour. Lightly spray the picture with fixative to prevent the pastel colours flaking or smudging.

Index

Page numbers in *italic* refer to illustrations

Acknowledgements

Illustrations:

Bridgeman Art Library (V & A Musuem, London) 59(r); Eaglemoss Publications (Humphrey Bangham) 53-58, (Brian Busselle) 29-34, (Diana Constance) 45, 107-112, 119-122, (Roy Ellsworth) 59-62, (Kay Gallwey) 39-44, (Dennis Gilbert) 47-52, (Lynette Hemmant) 73-76, (Jeremy Hopley) 7-12, (Jane Lompard) 46, 101-106, (Sally Michel) 35-38, (Ken Paine) 63-68, (Robert Pederson) 35-38, (Mike Pope) 113-118, (John Raynes) 13, 69-72, (Ian Sidaway) 7, 35-38, (Jackie Simmonds) 83-100, (Godfrey Tonks) 77-82, (Frances Treanor) 123-126, (Michael Whittlesea) 19-24; Dennis Gilbert 29(b); Peter Nahum 13(c); Philadelphia Museum Of Art (Bequest Of Anne Hinchman) 7; Walker Art Gallery 89(b); Michael Whittlesea 19(b); Eiko Yoshimoto 53(b); Kay Young 39(r).

Thanks to the following photographers: Julian Busselle, Michael Busselle, Mark Gatehouse, Nigel Robertson, John Suett, Steve Tanner.